THE ARTS AND HUMANITIES ON ENVIRONMENTAL AND CLIMATE CHANGE

The Arts and Humanities on Environmental and Climate Change examines how cultural institutions and their collections can support a goal shared with the scientific community: creating a climate-literate public that engages with environmental issues and climate change in an informed way.

When researchers, curators, and educators use the arts and humanities to frame discussions about environmental and climate change, they can engage a far wider public in learning, conversation, and action than science can alone. Demonstrating that archival and object-based resources can act as vital evidence for change, Sutton shows how the historical record, paired with contemporary reality, can create more personal connections to what many consider a remote experience: the changing climate. Providing valuable examples of museum collections used in discussions of environmental and climate change, the book shares how historic images and landscape paintings demonstrate change over time; and how documentary evidence in the form of archaeological reports, ships logs, Henry David Thoreau's journals, and local reports of pond hockey conditions are being used to render climate data more accessible. Images, personal records, and professional documents have critical roles as boundary objects and proxy data. These climate resources, Sutton argues, are valuable because they make climate change personal and attract a public less interested in a scientific approach. This approach is underused by museums and their research allies for public engagement and for building institutional relevancy.

The Arts and Humanities on Environmental and Climate Change will be most interesting to readers looking for ways to broaden engagement with environmental and climate issues. The ideas shared here should also act as inspiration for a broad spectrum of practitioners, particularly those writing, designing, and curating public engagement materials in museums, for wider research, and for the media.

Sarah Sutton is a long-time museum professional with significant expertise in environmental and climate issues. She is the CEO of Environment & Culture Partners, a nonprofit organization that accelerates change in the global cultural sector by designing and leading cooperative projects in climate action for global benefit. Sutton is also the author of *Environment Sustainability at Historic Houses and Museums*, and co-author of two editions (as Sarah Brophy) of *The Green Museum, a Primer on Environmental Practice*.

THE ARTS AND HUMANITIES ON ENVIRONMENTAL AND CLIMATE CHANGE

Broadening Approaches to Research and Public Engagement

Sarah Sutton

Routledge
Taylor & Francis Group

LONDON AND NEW YORK

Cover image: Fishing journals, including two from Dr. William L. Sutton. Photo by Taylor Brophy

First published 2023
by Routledge
4 Park Square, Milton Park, Abingdon, Oxon OX14 4RN

and by Routledge
605 Third Avenue, New York, NY 10158

Routledge is an imprint of the Taylor & Francis Group, an informa business

British Library Cataloguing-in-Publication Data
A catalogue record for this book is available from the British Library

ISBN: 978-0-367-49144-4 (hbk)
ISBN: 978-0-367-49145-1 (pbk)
ISBN: 978-1-003-04476-5 (ebk)

DOI: 10.4324/9781003044765

Typeset in Bembo
by SPi Technologies India Pvt Ltd (Straive)

CONTENTS

FIGURES

ACKNOWLEDGMENTS

There are many kinds of supporters in climate work and in writing: the cheer-leaders, the team members, the information sources, and the co-thinkers. I would like to thank them all. This includes every single museum and cultural heritage colleague in this climate fight—keep on it!

My special thanks and debts go to Elizabeth Wylie who started me on this life-changing journey, Sarah Nunberg who boosted it in the middle, and Stephanie Shapiro who has been there nearly from the beginning and is now making all the difference in scaling the work beyond my hopes and dreams.

For getting this book to print, my deepest thanks go to Denise Mix who is, fortunately for me, willing to partner again and again to create something that makes us both proud.

For his journals and his example, I send my love to Dr. William L. Sutton.

For contributions of inspiration and information I'd like to thank Bonnie Styles, Kirstin Drzwiza, Ben Haavik, William Flynt, Raney Bench, Catherine Schmitt, David Wood, Carol Haines, Jessica Desany Ganong, Monica Shah, Torrey Rick, Carter O'Brien, John Bates, Naomi Slipp, Nick Merriman, Todd J. Braje, and Timothy Walker.

And for thinking with me, I'd like to thank Erica Lawton and my students, only some of whom I am able to include here, in my Harvard Extension School classes for *The Anthropocene isn't just for scientists*: Elizabeth Abrahams Riordan, Christine McKinnon, Anne Scott-Putney, Jayme McLellan, Kate Tallman, Emma Rodgers, Anna Barber, Sophie Viandier, Brendan McLean, Rachel Hawkins, Tara Pawley, Brittany Brama, Kimberly Spencer-Baltzley, Tara Landers, Winona Van Alstyne, Porter Lesiv, Alexandra Carlson, Adam Davi, Christine Mondor, Sasha Myerson, Cassandra Baron, Jarek Adamczuk, Joe Perry, Anna Mudd, and Lisa Parrish.

I extend my sincere apologies for any errors or omission in acknowledging the support by anyone listed here, or not. Please let me know, I will gladly resolve this for the next edition.

INTRODUCTION

Museums' Humanities Resources as Allies for Science

The Arts and Humanities on Environmental and Climate Change: Broadening Approaches to Research and Public Engagement highlights the current work and future potential of researchers in science and humanities (cultural heritage) and asks them to think together to engage the public in creating a future where everyone and everything can thrive. As climate changes drive toward catastrophic for humans, we remain spinning in a debate over the scientific, social, and economic causes and effects of these changes, and over the ways to avoid the consequences. This cannot continue.

The current, most familiar illustration of the scientific evidence of climate change is two "hockey stick" graphs depicting the rise in global average temperature, and increases in CO_2e (all the greenhouse gases normalized and expressed in equivalent impacts of carbon dioxide or CO_2) in the atmosphere. The initial premise of climate-change-aware researchers and activists was that these facts will change minds and behavior. This has faltered on the assumption that humans are logical beings: we are much more than that. We humans are also emotional and political, inventive, and obstinate. The forces at work exacerbating climate change are equally varied and dynamic. It is not the fault of science that 50-plus years of evidence and education have failed to substantially shift our trajectory toward a healthier planet. It is a demonstration that the forces are greater than what science alone can illustrate or overcome, among them the independence of individual minds, and the alignments of identity, action, and belief (Fraser and Switzer 2021).

Some individuals have chosen not to accept the scientific evidence that the climate is changing. Many do not see themselves as directly connected to climate change. Others simply do not engage with the science if they do not see themselves as science-minded, prefer to learn without graphs and charts, or prefer to engage in other areas outside of science. Yet humans have used science *and* other modes of thinking and behavior to change the climate in one direction, already. We can choose to do so again.

DOI: 10.4324/9781003044765-1

The Arts and Humanities on Environmental and Climate Change: Broadening Approaches to Research and Public Engagement examines the valuable resources and perspectives found in cultural heritage that provide climate change evidence and may therefore be vehicles for reaching the museum publics not fully, or yet, climate aware. Many museums can expand upon the scientific discourse of climate change in ways that will reach these broader publics and tell a more complete story using examples and themes more familiar or relatable than scientific ones. By revisiting archival and object-based resources, by mining them for climate clues, museums can corroborate and enliven the scientific climate change data. Museums can use research, exhibitions, and programs to share under-used historical records and artistic materials from collections to build climate awareness and literacy. If museums combine that cultural heritage material with information from peer museum collections, governmental data sets, crowd-sourced community contributions, dispersed historical collections in both public and private hands, and community members, and then partner with the scientists to create fuller depictions of climate change, the process shares the burden of engagement currently placed primarily on science information. Alliances among scientists and cultural heritage practitioners could support the development of an increasingly climate-literate public. The results can engage members of the public who do not consider themselves scientists or interested in science, expanding the reach of this critical information.

The Use of Proxy Data for Making the Invisible Visible

Proxy data are representative data. Since the climate is not a measurable quantity, proxy data are used to represent changes in the climate. It helps us measure "climate transfer functions" or the degree of change in systems that are influenced by climate or, in turn, influence the climate. Climate change research already uses proxy information to register climate behavior over time. The most commonly examined proxies are paleoclimate data from "marine, lake, glacial, and speleothem cores and tree rings that reflect climate values ..." (Weiss 2017, 1). The most familiar example in public discourse is the measurement of greenhouse gases in the atmosphere as determined by sampling and measuring air trapped in ice cores taken from glaciers and polar ice. That use of proxy data in paleoclimate research is a model for using cultural proxies to understand and document the increased level of CO_2 since the beginning of the Industrial Age. This is at the center of Anthropogenic or human-driven climate change.

There are valuable climate change data not only in instrument readings but also in clamshells and maps, photographs and paintings, memories and traditional practices, town hall records, archaeologists' notes, newspaper clippings, land use patterns, and historical journals. Much of this material is cared for and shared by people in museums as tangible cultural heritage. These portals are everywhere, but museums have not yet vigorously used them to illustrate a changing climate in ways that can help more people understand and respond to the problem. Though the climate signals from fishing logs, restaurant menus, ice-out date-guessing competitions, butterfly club minutes, and artists' renderings are never so distinct as the

signals in ice core measurements for CO_2 and decades of temperature records, the stories are far richer, more complex, and more detailed than numbers alone can reveal. And so, these stories from personal journals, annual community events, monthly gatherings, and artists' close-looking and recording can complement the scientists' numbers in ways that help those bars and graphs, counts and percentages take on the feel of what any of us may encounter in our daily, personal lives.

What some scientists have done through documentary research has suggestions for all cultural heritage practitioners working with tangible and intangible materials. Through a museum's work, those approaches can support wider public engagement, even cultural diplomacy, around climate change based on science *and* culture. Sometimes the evidence is very accessible, as in comparative historical and modern photographs of Alaskan glaciers in the collection of the Anchorage Museum and accessible through a climate change finding aid prepared by intern Claire Berman (2018). Sometimes it is hidden in nearly forgotten, certainly undigitized ship's logs and merchant account books. Sometimes what is uncovered is more about environmental degradation and misuse than about climate change, making the story more complex yet a marvelous opportunity for illustrating the critical thinking necessary for understanding a changing world. For example, in historical menus, there are clues to fish availability that have potential connections to climate change, but more clearly tell a science-buttressed story of environmental damage and of "status, ethnicity, and evolving perceptions of food …" (Braje and Lauer 2020, 4).

Occasionally one discovers a particularly powerful source and story. The climate signals in Henry David Thoreau's *Journals* (1837–1846) are more complex and challenging to decipher than comparative photos of glaciers may be, but they become clearer when aligned with corroborating formats to highlight their proxy roles. Richard Primack found Thoreau's *Journals* to be not only a climate phenomenology treasure trove and a historical botanist's dream, but a demonstration of the power of data and observation to drive more research. In Primack's case, his journal-based research led to an inquiry into birds, butterflies, and other insect populations, and to partnerships with historic and modern birders and amateur botanists to extend the research (Primack 2014; Primack and Miller-Rushing 2012). The example of Thoreau's *Journals* and the other writings of his time on Concord's Walden Pond beautifully illustrates how smoothly documentary resources can engage a broad and passionate audience: they are a historian's delight, a philosopher's companion, and a tourist's bible.

To climate researchers it is not surprising that the evidence appears in so many formats; it is only surprising that cultural heritage practitioners working in museums have overlooked it so substantially. There is a broad menu of contexts for climate discussions and, therefore, a very broad platform for public engagement in meaningful climate awareness, responsibility, and action.

Why Don't We Do This More?

If humanities resources are so rich and the collaborative potential so great, why is it uncommon to find them in climate change exhibits and programs? How did the arts

and humanities remain separate? The blinders of a mission-driven focus may be a major contributor. The museum profession has assumed the validity of and reinforced the concept that such focus equals strength, quality, and professionalism. The museum sector has pursued mission-based distinctiveness that can isolate while encouraging competition. Museums' missions articulate their distinctive value and responsibility as charitable institutions; they refine and define work that differentiates institutions for the purposes of dividing and attracting funders, partners, and audiences.

While a visitor can see climate change evidence in the fossil record in natural history museums, hear stories in history museums, see current artistic commentary in art museums, and uncover solutions in science museums, that visitor is unlikely to see a sufficiently whole story in one museum, hear from one storyteller, learn from a scientist, or see with an artist. This segregation is what the public has been taught to expect, since science museums are most often devoted to science and other museums to history, with only some overlap. The need for museums to reorient their work toward social needs is a common conversation in the sector today, including responding to climate change. This reflects the continued shift of the field's approach from primarily inward-looking to outward-driven. The complexities of addressing social needs go far, far beyond the capacity of single-focus missions, and will not be addressed with siloed work and thinking. As Miranda Massie, Director of the Climate Museum in New York City, says: we have to get climate change out of the 'science silo' (Schlossberg 2021). While a topical focus reinforces mission-driven prioritization, it is quickly overwhelmed by a complex topic such as climate change. In present times, a topical focus is no longer effective or sufficient; it no longer supports a museum's professional and social value.

This clear delineation was not always there in the work by the professionalization of study and instruction. And it does not have to remain so siloed. Among the many legacies of Alexander von Humboldt is his conclusion that everything is connected (Körner and Spehn 2019, 1061). The 19th-century scientist's training, observational skills, and explorer's curiosity; his extensive network of worldwide correspondents sharing data, measurements, observations, and insights; and his humanist interest led him to conclude that "science is an important way to know the world, but it is one among many. Knowing of the world intellectually and aesthetically is enriching and empowering, and strengthens our bonds with nature and humanity, and our respect for both" (Jackson 2019, 1075).

Somehow these allies, the arts, sciences, and the humanities lost each other. While "science and art have been connected for more than 20,000 years" (Fraser and Ardalan 2020, 1), the current appreciation for these approaches is "stereotypically thought to be at opposite ends of the intellectual spectrum" (2). They reference authors Wright and Linney (2006) and the characterization that art is more "comfortable with uncertainly" (2), while science seeks to avoid uncertainty, searching for answers even as it pursues questions. Some argue that, indeed, the collaboration of arts, sciences, and the humanities would "enrich the results" (Fraser and Switzer 2021, 2). There *are* exciting examples in climate history demonstrating these enriched results. We need more of them, and museums can provide them.

Many museums are perfectly positioned to provide sources and collaborate with researchers to create more engaging climate stories. The threats of the climate crisis *must* force museums into this improved practice.

This book provides some provocative examples and a clear call for deeper work that will require deliberate efforts in multidisciplinary systems thinking. The climate story is a mix of interactive systems: climate systems, ocean systems, weather systems, ecosystems, and social systems. For researchers, a systems thinking approach *is* critical for establishing scientific, cultural, *or* historical context. It is equally critical for establishing climate context. Where museum workers may tend to think first of objects and themes to create content and to order thoughts and information, communicating climate change information requires thinking of whole stories of cause and effect, and intended and unintended impacts, often with objects in those stories alongside the processes that made the objects, gave them value, and brought about change. Climate change research requires looking for climate signals and patterns, and allowing for dynamism and as-yet-unanswered questions. Rather than solely measured results, there will also be recognizable shifts in the scientific, cultural, or historical record; the kinds of shifts that illustrate a change in ways that are meaningful to many, not only to scientists.

And so, the data sets must reach outside the science.

The irrefutable-data approach to climate convincing is based on commonly held, misguided assumptions that data change minds, and information is enough to change behavior. After 50 years of climate data conversations, too few minds have changed enough to slow climate change. So, what's missing? We're not sure (or we would be making more progress) but there are clear indications that an important issue we have overlooked is a less empirical one: identity (Fraser and Switzer 2021). Is the person who encounters our data and our information a person who sees themselves as a scientist? As a "numbers person?" Does the material they encounter, or the experience in your setting, encourage them build their own knowledge about their connection to nature, or their ability to create change? Do they see the connection that climate change has to what has meaning for them?

What if the museum profession broadened the range of touch to people who are more likely to be engaged in other ways, as diners, historians, archaeologists and birders, collectors, photographers, joiners, typists, fishing competitors, casual bettors, local promoters, hunters, crafters, and hikers? What if the profession started conversations in all those places? Then it might put more audience members on a path to considering climate change more thoroughly, and in a manner that places those audience members within the story, and with a new role to play.

With this in mind, this book takes two approaches. In Chapters 1, 2, and 3, I examine the use of science and cultural heritage materials in climate-related research. Chapter 1 explores how scientific research that includes museum collections demonstrates this is not a just-the-numbers approach. Chapter 2 examines how cultural research can do the same. Chapter 3 explores what researchers are learning about how to use cultural materials more effectively to do this research more completely.

In Chapters 4 and 5, my focus is outward-looking as I encourage the use of proxies to engage visiting and community publics, and for climate diplomacy. There is far too little of this to call on just yet, but hopefully, these pages encourage more institutions to share their work and others to begin it. Chapter 4 examines exhibit and program opportunities. To be clear, your climate case is not expected to be *the one* that triggers immediate action, but it may and can be an important building block in the public's willingness and capacity to support lifelong engagement. It can contribute to that steady piecing-together of who we are, what we know and love, and what we're going to do about it. Chapter 5 examines this untapped value of documentary evidence in the diplomacy domain, where climate change action is critical but agreement is illusive and negotiations struggle. It examines how shared values of national and global cultural heritage may be a valuable path to climate diplomacy.

The book concludes with a consideration of our next steps as a profession in expanding this work. It is currently emerging in our field, primarily among loose-knit groups of colleagues and individual institutions. The critical mass of interest is growing, as is the need for our response. This chapter examines what cultural heritage practitioners require to be able to advance and expand this work. The last three chapters, in a future edition, can only be sufficiently expanded if the arts and cultural heritage professionals help build that narrative.

How This Book Is Distinctive

The feature that distinguishes this book's material from those broader examinations of environmental humanities, climate history, and ecocriticism is its emphasis on the role of cultural heritage materials in museum collections as proxies—an untapped resource for public engagement on climate change. It provides a foundational approach that aligns with and can support five related research genres: environmental humanities, ecocriticism, paleoclimatology, climatology, and historical climatology.

Serpil Oppermann and Serenella Iovino described the nature of the emerging field of environmental humanities in the opening of their edited collection *Environmental Humanities: Voices from the Anthropocene* (2017) with a quote from the University of Oregon's *Environmental Humanities* 2014 newsletter: "The environmental humanities contextualizes and complements environmental science and policy with a focus on narrative, critical thinking, history, cultural analysis, aesthetics and ethics" (1). Ecocriticism focuses on what literature and arts tell us about humans' relationship to nature. Karl Kusserow and Alan C. Braddock describe ecocriticism, in the preface to their monumental work *Nature's Nation: American Art and Environment*, as

> a mode of cultural inquiry developed from literary studies and environmental history … [which] now encompasses the study of ecological significance in artistic practices of all kinds … ecocritical inquiry looks beyond conventional humanistic frameworks by exploring neglected but pertinent evidence from environmental history and ecological thought.
>
> *(2018, 14)*

Paleoclimatology uses ancient natural archives, found in the environment or the earth in the fossil record, sedimentary layers, and ice cores. This is deep, geological time. Climatology is the study of climate through atmospheric and weather patterns over time. Historical climatology uses reconstructions of weather and climate from the period before nationally organized weather programs measured conditions. The data come from documentary evidence: anthropogenic archives or historical information captured by people (Mauelshagen 2014, 2).

Why This Book May Be Valuable to You

There is one more distinction between this book's approach to proxy data use and much of the work done to date. Most research on climate proxy data is searching for clues about how humans have adapted in the past to climate changes and how that knowledge may help us adapt to our climate change in the future. Though I agree on the value of such research, first we must learn to use proxy data to illustrate how the climate is changing, and how we know this to be, so that museums can use that knowledge to engage the public in understanding climate change as something that affects them and the people and places and things they are connected to and may care deeply about. *Then* learners can focus on adaptation.

This book will show you how humanities materials are valuable to understanding climate change. And it will help you explore ways to use cultural materials to improve public understanding of and connection to climate change. It will help you expand your use of materials and information through museums to examine historical evidence and experience, and connect them to climate change discussions. It is a call for mining collections of materials and memory to illuminate the changes over time that demonstrate how the climate system is changing and how those changes affect us and our families, our communities, and the world.

The materials, research, and program examples you will find in the following chapters illustrate how museums' humanities materials are valuable for identifying, describing, and illustrating climate change in a manner that always includes science, has multiple contributors, and reflects multiple disciplines. The integrated approach improves perspective, expands foundations, strengthens rigor, and co-creates knowledge and curiosity for valuable resources even as it raises the next set of questions. Connecting to cultural heritage enriches and expands the conclusions and explanations, anchoring both science and humanity.

References

Berman, Claire. 2018. *Climate Change Photography Resource Guide*. Anchorage, Alaska: Atwood Resource Center, Anchorage Museum. https://www.anchoragemuseum.org/media/12164/climatechangeguide.pdf

Braje, Todd J., and Matthew Lauer. 2020. "A Meaningful Anthropocene?: Golden Spikes, Transitions, Boundary Objects, and Anthropogenic Seascapes." *Sustainability* 12, no. 16 (August 11): 6459. https://doi.org/10.3390/su12166459

Fraser, John, and Nezam Ardalan. 2020. "Reflections on Science, Art & Sustainability." Brief following A2A: Awareness to Action, Science, Art, and Sustainability 2018 Workshop. https://www.datocms-assets.com/15254/1579632107-reflections-on-sci-art-sustainability-2020-01-13.pdf

Fraser, John, and Tawnya Switzer. 2021. *The Social Value of Zoos*. Cambridge: Cambridge University Press.

Jackson, Stephen T. 2019. "Humboldt for the Anthropocene: Humboldt's Fusion of Science and Humanism Can Address Contemporary Challenges." *Science* 365, no. 6458 (September 13): 1074–1076. https://doi.org/10.1126/science.aax7212

Körner, Christian, and Eva Spehn. 2019. "A Humboldtian View of Mountains." *Science* 365, no. 6458 (September 13): 1061. https://doi.org/10.1126/science.aaz4161

Kusserow, Karl, and Alan C. Braddock. 2018. *Nature's Nation. American Art and Environment*. New Haven: Yale University Press.

Mauelshagen, Franz. 2014. "Redefining Historical Climatology in the Anthropocene." *The Anthropocene Review* 1, no. 2 (June 27): 1–34. https://doi.org/10.1177/2053019614536145

Oppermann, Serpil, and Serenella Iovino, eds. 2017. *Environmental Humanities: Voices from the Anthropocene*. London: Rowman & Littlefield International.

Primack, Richard B. 2014. *Walden Warming: Climate Change Comes to Thoreau's Woods*. Chicago: The University of Chicago Press.

Primack, Richard B., and Abraham J. Miller-Rushing. 2012. "Uncovering, Collecting, and Analyzing Records to Investigate the Ecological Impacts of Climate Change: A Template from Thoreau's Concord." *BioScience* 62, no. 2 (February): 170–181. https://doi.org/10.1525/bio.2012.62.2.10

Schlossberg, Tatiana. 2021. "The Climate Museum Is the First of Its Kind in the U.S. — and Its Founder Is on a Mission." *The Washington Post*, September 10, 2021. https://www.washingtonpost.com/climate-solutions/2021/09/10/museum-miranda-massie-art/

Weiss, Harvey. 2017. "Collapse! What Collapse? Societal Adaptations to Abrupt Climate Changes before Global Warming." Yale University, Humanities Workshop proceedings, October 20–22, 2017. Accessed September 25, 2021. https://whc.yale.edu/sites/default/files/files/Collapse!WhatCollapse%20workshop1(1).pdf

Wright, A., & Linney, A. 2006. "The art and science of a long-term collaboration." In D. Rye, & S. Scheding (Eds.). *Proceedings of the New Constellations: Art, Science and Society* (pp. 54–60). Sydney, Australia: Museum of Contemporary Art.

1

HOW COLLECTIONS MATERIALS CAN DOCUMENT CHANGE OVER TIME

Museum Collections as Environmental Change Resources

Researchers in collections at natural history museums use objects and materials to tell larger stories, including those on the environment and climate (Oliviera et al. 2020, 339–340). There are a few iconic examples of scientists using the resources of museum collections to build cases illustrating environmental conditions and/or environmental change that are the example for using museum documentary collections to illustrate climate change. The iconic examples were scientific research projects that examined collections materials for data to establish a baseline of information or conditions, a change over time, or to compare different data types to build a more complete picture of the historical ecological phenomenon. Natural history museums may seem the preeminent genre for the climate change discussion, yet *all* museums and their collections are valuable settings for significantly widening research and public engagement and facilitating a dynamic, multi-public approach to addressing changes in the climate system. Their work is a clear illustration of the broader potential of objects as proxies in climate documentation.

The examples that follow begin with how museums have used or are using their collections to identify anthropogenic or human-driven *environmental* changes over time. The next section examines what is proxy data, *not necessarily from museums*, and how and why it is used in scientific research on *climate change*. And the last examples introduce how scientific materials *in museums* are emerging as proxy resources for studying *climate change*. There are many more examples of environmental research in collections than climate change research in collections, and many more examples of scientific proxy data being used to describe climate change than humanities proxies. These approaches, using museum collections to detect changes and using proxy data in scientific collections materials to describe

DOI: 10.4324/9781003044765-2

climate conditions and climate change, are the foundation for an emerging practice of using cultural heritage collections in museums as proxy materials for documenting climate change.

Natural History Museum Collections as "Durable Snapshots"

United States museums offer some iconic examples of research in natural history collections that deepened the understanding of environmental conditions. These examples set the scene for re-review and expanded review of all collections to inform approaches to issues that can be illustrated by materials and memory over time. The first is the 1968 work by Joseph J. Hickey and Daniel W. Anderson on the connection between the presence of the insecticide dichlorodiphenyl-trichloroethane (DDT) and the reduced thickness of eggshells of raptors and other fish-eating birds, therefore diminishing the shell strength and the likelihood the embryo and chick will survive. The second research example was published in 2017 by Shane G. DuBay and Carl C. Fuldner examining 135 years of bird specimens collected from the US industrial belt that connects the cities of Detroit, Chicago, and Pittsburgh, and the states of Ohio, Michigan, Pennsylvania, and Illinois, and the incidence of black carbon, or soot, on their feathers. Both cases use materials in museum collections to reveal human impacts on the environment. Both cases use animal specimens (i.e., bird species), an animal type that is widely recognizable to the public, and whose eggs and bodies can be examined, displayed, and described to illustrate a historical phenomenon in personal, tangible, and relatable ways.

In the absence of the ability to directly measure black carbon in the atmosphere in the US industrial belt, or DDT levels in the American waterways and impacts on wildlife in the mid-20th century, or how much plastic industries and users have let slip into waterways, researchers can find proxy data in museum collections. A 1968 study examined eggshells to determine if there were detectable variations in thickness attributable to the presence of a chlorinated hydrocarbon, DDT, known to remain present in the environment for a long time and to accumulate in animal tissue. The research query responded to eggshell thinning and serious bird population declines noted in Britain and possibly occurring similarly in the USA. DDT had been in use in the USA since the 1940s and became a concern in the 1950s and 1960s for its lasting health impacts on wildlife and possibly humans. Today the World Health Organization sanctions its use only indoors and in areas where malaria is prevalent and lethal (Environmental Protection Agency n.d.). In 1967, with DDT suspected as the cause of some species' viability, the researchers collected eggs from bird colonies with declining *and* stable populations, with a mix of fish-dependent and non-fish diets, for comparison. They compared shell thickness and chemical makeup of nearly 2000 blown (intact but emptied) eggs in 39 museum collections (not all museums were identified in the research) where the specimens, according to the collector's records, had been sourced from the same species and region. The researchers selected 29% of the specimens for non-invasive testing. They used the holes drilled by the original

collector to blow the eggs as the measuring point to test the shell thickness and create a baseline from the period before the chemicals were introduced to the environment. Their work demonstrated that where birds had a fish-based diet, contemporary populations were at risk because of egg failure resulting from "changes in calcium metabolization" caused by the chemical, reducing the calcium in the egg as it formed and driving the parents to eat eggshells as a source of calcium. This was not the case with contemporary populations eating non-fish diets, or with the historical collections pre-dating the use of DDT, whether or not the birds consumed fish for their diet (Hickey and Anderson 1968; Bates 2017). The results show how museum collections materials can provide benchmarks for illustrating change over time: "Natural History collections are powerful resources for tracking environmental pollutants through time because specimens provide durable snapshots of the past environments from which they were drawn" (DuBay and Fuldner 2017, 11325).

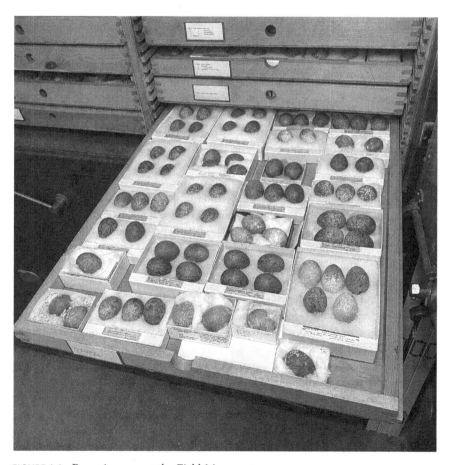

FIGURE 1.1 Peregrine eggs at the Field Museum.
Photo by J.M. Bates.

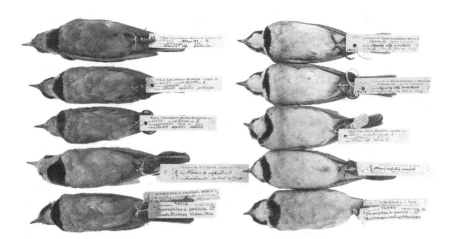

FIGURE 1.2 Horned Larks, 1904–1926, Field Museum, 2015.
Carl Fuldner and Shane DuBay.

Another recent study of natural history collections provides evidence of how collections can illustrate changes in physical pollution, rather than chemical. In this case, collections materials illustrate the resulting changes when human behaviors changed due to policy interventions regarding an environmental issue. A 2017 study of bird specimens at the Field Museum focused on the presence of black carbon, the soot produced by burning coal, particularly soft or bituminous coal. Imagine the US industrial cities of Detroit, Pittsburgh, and Chicago, part of the US industrial belt during the early 20th century. These cities were hubs for national railroads, centers for steel production and coal processing, and manufacturers of trucks, equipment, and all manner of the Industrial period goods. Coal use left its marks on the environment as industries burned the fossil fuel to run manufacturing processes, trains burned coal to transport goods, and people burned it to heat their homes. The soot accumulated on buildings and windows, hung in the air, dirtied fresh laundry hung to dry, and settled on the landscape and the wildlife. This soot accumulation is obvious on the feathers of specimen birds in the museum's collection. It was confirmed under close examination of individual feathers.

By using a scanning electron microscope, the authors demonstrated that the carbon adheres to the feather. The feather becomes discolored by the black carbon. This is confirmed by examining a similar specimen collected in the same area but in the time just after its annual molt when the new replacement feather has not yet had time to accumulate soot. The Field's collection includes widely distributed examples, making it a historical baseline for that region. Since these specimens pre-date any reliable, organized mechanical air sampling for pollution control by 70 years, they are an indicator of environmental impacts. They are proxy data for when there is no direct sampling record to examine. The specimen record shows a change from the early 1900s to the 1950s and 1960s. By the mid-20th century, carbon deposits on these birds no longer rise in tandem with the use of coal in the region. There

was continued coal use but less evidence of carbon deposits on the birds. To explain this, the study authors examined the local regulations that would affect the amount of coal particulates released into the air. These regulations required mechanical control of pollutants when burning bituminous coal. While companies could afford this equipment, it was prohibitively expensive for residents using coal for home heating or cooking. As a result, domestic use of bituminous coal dropped, and manufacturing and other industries reduced their emissions somewhat. To reach this conclusion, the study authors examined public policies and laws governing air pollution. Their example demonstrates how collections specimens can be useful in documenting change over time, and that museum resources can improve understanding of cause and effect, and impacts. Rarely is there a single historical factor driving results; understanding the panorama of influences on the climate and social systems is important for telling an interesting and exact story.

A more recent and not yet iconic study resurveyed museum collections for scientific evidence of human impacts on the environment. Researchers at the Field Museum conducted a survey of freshwater fish specimens in the collection, identifying the absence or presence of plastic microfibers in preserved fish specimens collected between 1900 and 2017 also in museum collections, and compared to contemporary sampling from the same locations in 2018. The study concluded that there were no microplastics found in any fish prior to 1950 (though there was contamination), and the combined concentrations of microplastics in the four types of fish sampled demonstrated "a significant increase" of fibers made of plastic polymers and mixtures of natural and synthetic materials (Hou et al. 2021, 2320). The most significant indicator of how much plastic would be found in a fish was the period and date when the fish was collected for the museum. The museum's collections were the key element in the research study (Hou et al. 2021, Johnson 2021).

In side-by-side images of the blown eggs or bird specimens, the contrasts turn the abstractions of the percentage decrease in egg wall thickness and the increase in carbon deposits into both beauty and tangible loss. In these ways, collections illustrate changes in practical and emotional, visual, and even tactile ways that may be more accessible and interesting to a wider visitorship for learning and engagement. They can reinforce other data when making a case to professionals and lawmakers addressing resource protection and planning, and developing regulations and policies.

Documenting Climate Change in Collections Materials

The climate was here before humans' instruments could measure it. Since the instrumental record largely coincides with the advent of human impact on climate through extensive agriculture and then the burning of fossil fuels, "We don't have an instrumental record of what the climate was like in its more natural state …. We need paleoclimate proxies to understand what the 'natural' climate, one without large-scale human interference, was like" (Trouet 2020, 77). So, how do we look at weather and atmosphere in this 'natural' state from *before* widespread instrumentation to understand change over time, particularly climate changes?

As discussed in the introduction, paleoclimatology uses ancient natural archives, found in the environment or the earth in the fossil record, sedimentary layers, and ice cores to study deep, geological time. Climatology is the study of climate through atmospheric and weather patterns over time. Historical climatology uses reconstructions of weather and climate from the period before national weather programs using "anthropogenic archives" or historical information captured by people rather than "natural archives." The anthropogenic data would be information from instruments, in ship's logbooks and farmers' records, and in "reports about costs of maintaining dikes" (Pfister et al. 2001), etc. Both types of information—the ancient geological record and the anthropogenic data—are proxy data: they represent a phenomenon when the phenomenon itself cannot be measured. These data can help reconstruct earlier conditions over years, centuries, or longer, and can be compared to present data to help us understand climate change.

Proxy Data

The Intergovernmental Panel on Climate Change (IPCC) is the scientific body charged by the United Nations with coordinating the collection, interpretation, and publication of scientific information associated with climate change. The IPCC's audience is policymakers who need to understand current assessments of the causes and impacts of climate change, anticipated risks, and methods for addressing and adapting to it. Volunteer science advisors are assigned to working groups, of which Working Group I (WGI) focuses on the scientific basis for climate change. It uses proxies. The researchers identify paleoclimate proxy indicators for climate change, the scientific parallel for those in cultural heritage collections in more recent times.

> A 'proxy' climate indicator is a local record that is interpreted using physical or biophysical principles to represent some combination of climate-related variations back in time. Palaeoclimate proxy indicators have the potential to provide evidence for large-scale climatic changes prior to the existence of widespread instrumental or historical documentary records.
>
> *(Folland et al. 2001, 130)*

The WGI report lists important examples such as tree-ring records, corals, ice cores, lake and ocean sediments, and borehole measurements as proxy data. In the United States, the Department of the Interior divides these and others, all paleo proxies—those evident in geologic materials—among three categories: physical, biological (terrestrial and aquatic), and chemical. Within those, natural proxy data come from nature (e.g., fossil pollen); anthropogenic proxies are human-made (e.g., journals and eyewitness reports).

The collections data examined so far in this text are mainly biological proxies. Where, then, would we place the aerial photography? Or the travel itinerary data? Or the notes from a 1940s archaeological dig? They are cultural proxies. This is

the heart of the case for cultural materials collections telling climate stories: climate research already uses proxy data to corroborate climate attributes over time, including its changes. The preponderance of scientific sources reflects the research practice to date, not the availability of evidence. The proxy data available in cultural materials add credence to the phenomenon of climate change, and can support understanding for other audiences.

By definition, proxies are indirect indicators; some are more indirect than others. The variations manifest more as gradations than differences. As an example, the United States Geological Survey (USGS) describes CO_2 trapped in ice cores as a "relatively direct" proxy, having been captured in the ice as an immediate indicator of the presence of CO_2 in the atmosphere at the time the water froze. The aspect of CO_2 being captured in ice makes it direct. It is frozen at that time without any interference from physical or other forces. Documentary data can be direct or indirect. If the documentation is data captured daily by a sailor in a ship's log, then it is a direct record of conditions at the time. Researchers categorize direct data as

> descriptive documentary data, e.g., narrative descriptions of weather patterns or early instrumental measurements as direct data. Indirect or documentary proxy data reflects *the impact* [emphasis added] of weather on elements in the hydrosphere (e.g., floods and low water tables), the cryosphere (e.g. duration of snow cover) or the biosphere (e.g., phenological data).
>
> (Brázdil et al. 2005; Pfister and Brázdil 2006)

Of course, weather alone does not indicate climate, but rather the changing characteristics and impacts of weather over time can.

Another consideration for direct or indirect value of proxy data is if any forces may have affected the evidence observed as a proxy indicator. The USGS gives an example of "less direct" indicators as the measurements of carbon in the shells of ocean creatures because the oceans' and the organisms' intermediary processes affect the rate of absorption. To use CO_2 levels in ocean creatures as an indicator then requires "calibrating" them in ways that establish previous and subsequent levels, and the impacts of any other mediating factors, "to establish a relationship between climate processes and the proxy" (USGS Proxies+ nd.)

Dendrological Materials

WGI identifies dendrological or tree-ring data as proxy data. Dendrologist Valerie Trouet explains that "with trees and forests covering large swaths of the Earth's surface, tree-ring data are some of the most commonly used climate proxies, especially for the most recent 1,000 to 2,000 years, the period with the most dendrological data" (2020, 68). These data are a marvelous representation of decades-to-centuries-to-millennia information in a single long-lived specimen or in a series of overlapping samples. Dendrologists source these specimens carefully with thin bores from living trees, in substantial "cookies" of cross-cut samples from whole trees, and in

the record found in archaeological sites and shipwrecks, or in wooden buildings still present in our cities, countrysides, and remote locations. There are also much data to be found in docks; in the wooden walls in wells; in furniture, panel paintings and picture frames, wooden sculptures, and musical instruments; and tools and kitchen implements.

Dendrologists compare tree-ring data to instrumental records to calibrate the tree data. A shorthand version goes like this: trees grow more in the spring period, after a rest, with the advent of suitably warm and moist conditions. Various tree species of course have differing characteristics, but generally the faster-growing wood creates the most width. This earlywood is distinctive from the latewood or fall and pre-dormancy growth that is relatively slower, often due to colder temperatures and drier conditions. The contrast from latewood to earlywood is usually so stark as to show a line or ring demarking a year's growth before the sequence begins again. That line sequence is the annual record used to match other records—instrumental or historic—to establish the period of growth for the particular tree. When someone needs to date a wood section and verify her conclusions, she cross-dates it by comparing the tree-ring pattern to a likely overlapping tree-ring pattern in another wood source. When it is an exact match, the pair now reflects a continuing record from the earliest dated ring on one, to the latest ring on the other, with an overlap sequence in the middle. In this manner, a chronology can be lengthier than the growth period of a single tree specimen (Trouet 2020). Another wood sample can be compared to that series to date it to establish the timing and frequency of climate-revealing events shown in the tree's growth or scarring.

The natural growth of trees records the influence of climate—whether ancient or anthropogenic. The width and density of a tree's rings reflect its environmental situation such as precipitation levels reflecting drought which limits growth or abundant rain that spurs growth. Sometimes a break or a partial thickening of a ring or rings can reflect dramatic events experienced at that location by that tree. These may be direct interference from animals and humans; natural events such as avalanches, mudslides, or tornados; and events that can be tied to changes in climate such as severe drought and flood, and storms and fires. Sorting out the environmental and human "noise" from the climate evidence is similar to sorting through any data to establish historical context. The researcher must identify the "who," "what," "when," "how," and "why" of these conditions and their influence on the material or information. This is one reason why the use of tree-ring data as proxy data is the scientific proxy approach most like the use of documentary data as proxy data. It is not done using instruments but using information that can be calibrated to instrumental records to expand and enliven the story.

How to Use Non-instrumental Proxy Data

Weather—as in temperature, pressure, and moisture—is often but not always described in numbers. What if the farmer had no thermometer but noted conditions as "dry," "very dry," and "unusually dry," or the miller did not record

temperature but instead the bushels of wheat brought to grind? How do we turn that narrative data into numbers? And how do we standardize that process so that it is transferrable and reliable? One person's "heavy rain" might be another person's "rainstorm moved in" entry. This is where the historian's familiarity with the topic and the source is so important, and where two methodologies have been proven to be reliable and transferrable. These are calibration-verification and indexing.

The calibration-verification approach, with tree rings or documentary data, focuses on time-series information, sequential dates, or events, aligning or comparing a confirmed reference example and the one being tested using a shared and very distinctive marker where the time series overlap each other. That marker is a datable event or impact that can be seen in the material, such as the distinctive width or appearance of a tree's growth rings, or a notation in a dated journal or government record. The goal is to find where the pattern, or the distinctive signal, appears in two or more samples, one of them already proven as an accurate record of that time period. Where the time series overlap, the researcher validates the alignment of the new data by comparing its appearance to the appearance of the proven sample, aligning the reference point with the indicator in the known sample (Huhtamaa 2020; Pfister and Brázdil 2006). This is calibration. Once you know that the new data series is calibrated with an independent proven dataset, you can use it to document changes over that specific period of time.

For data that do not occur in a series, but may appear in several documents or document collections, indexing can provide a comparative basis. This index approach focuses on the proxy data itself, rather than a comparison process. The researcher examines enough material to identify the extent of the information, then examines patterns and variety in the information, and finally creates a numerical scale for describing and comparing the indicators within the material. For example, when comparing temperature descriptions in a group of documents, the label −3 would be extremely cold and the label +3 would be extremely warm (Huhtamaa 2020). Studies of data from Central Europe have demonstrated the reliability of using an index to compare non-instrumental or documentary observations over a specific period with instrumental measurements of temperature or precipitation for the same period (Pfister and Brázdil 2006). The field requires more examples of this to develop a more widespread understanding and practice of its use. It could unlock significant amounts of localized data currently hiding in cultural heritage materials.

Exploring atmospheric pressure is another way to understand more about the weather during a given period. Weather over long periods of time or unusual shifts in weather can indicate changes in climate. But how do you measure past, pre-instrumental atmospheric pressures? One way is to work backward from what is already known. An example is the use of documentary proxy data from sites in Eurasia (Luterbacher et al. 2002). The authors captured instrumental data for the 1901–1990 period. Then they took documentary evidence from 1901 to 1960 and compared it to the instrumental data from that time period to develop an understanding of the relationship between the documentary data and the instrumental data. They learned to recognize how the documentary data would be reflected in

the instrumental data. They calibrated the documentary data to the instrumental data. Then they made assumptions about how the documentary data would affect instrumental data, and then tested their conclusions for a later time period of 1961–1990 to verify and calibrate the data. This is the historical climatological version of educated guess-and-check. Once they were confident that they had the right assumptions, they used those functions to run a regression analysis to 1500 to understand weather and climate.

Of course, not every curator wants to be a climate researcher. And some data are always clearer than others, requiring interpretation by either the scientist or the cultural heritage practitioners. Therefore, some data are identified as high quality with sufficient information to draw reliable conclusions: "specific information on weather elements (e.g. number of rainy days, direction of cloud movement, wind direction, warm and cold spells, freezing of water bodies, droughts, floods, information on vegetation)" (Luterbacher et al. 2002, 546). That list also includes ice and snow features, and phenological and biological observation as "high-resolution documentary proxy data" (546). Lower resolution proxies are data that are more subjective and from less direct observations. This is where historical research and interpretive skills are so important. This is also why researchers and caretakers of collections have very valuable contributions to make to each. Not only will they share collections, but they can inform one another during the process of discovering and accurately using this crucial proxy data.

Using Scientific Collections Materials as Proxies for Climate Change

Now let's expand this approach to consider how collections materials are commonly used for finding signals of climate change impacts rather than evidence of environmental changes. The previously described bird specimen examples illustrated changes in environmental conditions that are not caused by a changing climate. Let's examine cases where natural history collections provided clues to or evidence of change to the climate system. These examples support the use of humanities resources for similar research.

Plant and animal communities respond to long-term shifts in conditions by adapting, if they can. They increase and/or expand their range and population if they benefit. They find their populations and ranges reduced and/or contracted even to the point of extinction if they do not benefit. If conditions become too dry or warm, mobile individuals and colonies of plants and animals will relocate to a more favorable setting. Animals may physically change their range during their lifetime and subsequent generations, and plants may over generations. If the rate of change is rapid, within a generation, and if individuals in the population are not mobile (e.g., a coral or oyster colony), much or all of a species in that location may die out completely. If the change is more gradual, then offspring sprouting or born on the edges of previously favorable conditions and newly favorable ones may be successful at establishing new ranges. These disappearances, and range shift or creep, are distinguishable in

the historical plant record by paleo approaches such as pollen records; historical and contemporary photographic records through aerial mapping and comparisons of interval photographs; and in the animal record through species counts and fossil records of animals dependent upon the plant. Present-day observations of plants, scat left by animals, and records of harvest or production provide current evidence for comparison of species density, range, frequency, absence, and arrivals.

To understand species loss in an area, the research questions are: Did the members move or die? Have other species been introduced or arrived, and found changed or changing conditions to be more beneficial here and so crowded out previous species? Were the missing species unable to relocate or survive *in situ*? Did the range shift elsewhere? This is where the "durable snapshots" found in natural history collections are so valuable. They document when, where, and how a species was present in the landscape.

Four researchers from US universities compiled examples of collections-based research that illustrated known climate change impacts: the spread of infectious diseases, changes to species diet, and migration and range. This study re-examined historical locations of species noted during an early 20th century museum-sponsored survey and compared the record to today's observation. The hypothesis was that the historical data were a baseline and the present data provided a comparison that would reveal climate change signals. The researchers wrote:

> One of the best examples of the potential of museum collections to document climate change is the Grinnell Resurvey Project. From 1904 to 1940, Joseph Grinnell and colleagues from the Museum of Vertebrate Zoology (MVZ) at the University of California, Berkeley, collected and thoroughly survey the terrestrial ecosystems of California and the western United States to document vertebrate diversity in time and space. Their legacy of specimens, meticulous field notes and photographs are a veritable 'gold mine for investigations of species' responses to climate change, changes in human land use and other stressors.'
>
> *(Schmitt et al. 2018, 5)*

When this baseline was compared to conditions in the early 21st century for the Grinnell Resurvey Project, the results demonstrated "on average, the ranges of 14 species shifted 500 m upwards" (5) in Yosemite National Park in a manner that is "consistent with a 3°C increase in temperature recorded between historical and contemporary surveys" (5). The concern of this climate-driven shift is the survival challenge for species: those in high elevations will only be able to go so much higher before reaching the mountain top as climate change progresses. This leads to smaller population ranges and population fragmentation, and to overcrowding in some areas and genetic isolations in others—all of it shifting the ecosystem, and none of it good for the survival of the present species. Anyone who has imagined or experienced climbing to safety to escape fire, flood, or capture, will recognize this struggle.

A similar resurvey of plant collections has valuable examples for identifying climate changes and impacts and risks. Researchers examined the use of plant collections in herbariums for assessing the risk of extinction due to environmental impacts of human behavior and climate change. They used herbarium collections to verify the extent of "the occurrence of particular plants at particular points in space and time" (Nic Lughadha et al. 2018, 1) as they assessed species' current extinction risk. They compared their assessments against those developed in the field by the International Union for the Conservation of Nature for its Red List, the list of species at risk of extinction, and found the results reliable. After testing five assessment approaches using herbarium specimens, they found that "when [herbarium] specimens represent the best available evidence for particular species, their use as a basis for extinction risk assessment is appropriate, necessary and urgent" (1). When fieldwork is impossible due to dangerous or unhealthy conditions and lack of funds or access, this alternative method is a very viable substitute.

The researchers explained the commonly accepted limitations to this herbarium specimen data, some of which we'll examine more closely in Chapter 3, but they add that

> for very old specimens, where only minimal locality data is reported on the specimen label, the collector's name, number and the collection date can often be combined with itinerary data from published or unpublished journals or travel accounts to infer collections localities. Such labour-intensive approaches for pinpointing older collections may be rewarded by invaluable insights into historic species ranges.
>
> *(3)*

This critical assessment of collections context is an expected practice by researchers in cultural collections, but the confirmation from outside the museum field that this work is reliable does reaffirm the documentary case. This process of completing the data story with humanities resources is where cultural collections support scientific inquiry, expanding the narratives to offer broader and deeper engagement opportunities.

Multi-factor Authentication

The early examples in this chapter established that the museums' specimen collections have value in documenting and demonstrating environmental and climate change, but rarely will they or any other data source, alone, sufficiently document climate as precisely as temperature does, at least for western science. This is where multi-factor authentication comes in, and where varied resources add layers to the documentation: it is valuable where an instrumental, direct-measurement approach is missing or lacks color and detail to tell a story sufficiently.

An example of this is a study of plant matter of the Laurentian Great Lakes (Lishawa et al. 2013), also known as North America's Great Lake system or inland

ocean (though it is of fresh water). It blended observation, paleobiology, and community historical sources to draw its conclusions. To document the extent of the invasion of plant species—in this case, two types of cattails—the study compared present-day coverage to a series of time-delineated stages of spread using archaeological pollen measurements and historical aerial photograph compilations. The older pollen data could provide a record for the period before aerial photographs were available and verify conclusions from aerial photographs where there is overlap. These cattail species are discernible from the air, whereas many species would not be. The pollen data came from sediment cores taken on site, and the photography from a mix of sources. The authors surveyed imagery from national, state, county, university, and private data sources, a mix of information from major online search engines' mapping tools, US National Archives and Records Administration, US Department of Agriculture, and USGS to compile scans of black-and-white and color photographs, and digital orthoimagery, the kind of scan that can take a photograph and create a digital version that eliminates distortions from the camera's angle or the terrain to create a more accurate image. Then they mapped the current spread of the cattails using field vegetation data by visiting the sites and making records with GPS units to create a map of existing conditions. To that, they applied proven photo-interpretation to identify stands of cattails and map their historical progression. The result is a demonstration of a multi-data approach using samplings of geological and humanities information to build an illustration of the environmental changes based on human impacts. It could be applied just as appropriately to identify expansion, contraction, and shift of plant species experiencing the impacts of climate change where those species can be reliably identified from the air by their texture, scale, shape, and hue (Lishawa et al. 2013).

Museums' Cultural Heritage Collections as Climate Change Resources

What then would be the direct and indirect examples of cultural heritage climate change proxies rather than environmental proxies? Direct capture of climate change evidence, the snapshots, would be photographs, contemporary depictions (drawings, sketches, paintings, etc.), human narrative, personal accounts that are shared as memory, and oral traditions and histories. What some scientists have done through documentary research has suggestions for all cultural heritage practitioners working with tangible and intangible materials—and not only scientists. Through a museum's work, those approaches can support wider public engagement, even cultural diplomacy, around climate change based on the sciences and humanities.

If the use of proxy data "is scientifically familiar but neglected in the social sciences" (Schaffer in Diemberger et al. 2012, 241); this is also true for the humanities. These collections materials are boundary objects "… adaptable to different viewpoints but robust enough to maintain identity across them" (Star and Griesemer 1989, 393). They offer "people from different scientific disciplines or different social worlds" a pathway "to come to a common understanding" (Sigfúsdóttir

2021, 430). Unfortunately, the bulk of the historical climatology research focuses on three or more centuries into the past, and has "yet to get involved in discussing the Anthropocene or in writing its climate history" (Mauelshagen 2014, 2). That should no longer be the case. Climate change research must use cultural heritage materials to illustrate the story of the Anthropocene, that period we live in now where humans, rather than planetary forces, have created a change so significant that it appears in the geological record of the planet. Let's examine how cultural heritage materials do just that.

References

Bates, John. 2017. "Eggshells, DDT, Collections, and Study Design." *Field Museum Blogs and Videos*, July 2, 2017. https://www.fieldmuseum.org/blog/eggshells-ddt-collections-and-study-design

Brázdil, Rudolf, Christian Pfister, Heinz Wanner, Hans von Storch, and Jürg Luterbacher. 2005. "Historical Climatology in Europe – The State of the Art." *Climatic Change* 70, no. 3 (June): 363–430. https://doi.org/10.1007/s10584-005-5924-1

Diemberger, Hildegard, Kirsten Hastrup, Simon Schaffer, Charles F. Kennel, David Sneath, Michael Bravo, Hans-F. Graf, et al. 2012. "Communicating Climate Knowledge: Proxies, Processes, Politics." *Current Anthropology* 53, no. 2 (April): 226–242. https://doi.org/10.1086/665033

DuBay, Shane G., and Carl C. Fuldner. 2017. "Bird Specimens Track 135 Years of Atmospheric Black Carbon and Environmental Policy." *Proceedings of the National Academy of Sciences* 114, no. 43 (October 24): 11321–11326. https://doi.org/10.1073/pnas.1710239114

Environmental Protection Agency. n.d. "DDT -- A Brief History and Status." Accessed December 30, 2021. https://www.epa.gov/ingredients-used-pesticide-products/ddt-brief-history-and-status

Folland, C.K., T.R. Karl, J.R. Christy, R.A. Clarke, G.V. Gruza, J. Jouzel, M.E. Mann, et al. 2001. "Observed Variability and Climate Change." In *Climate Change 2001: The Scientific Basis*, edited by J.T. Houghton, Y. Ding, D.J. Griggs, M. Noguer, P.J. van der Linden, X. Dai, K. Maskell, and C.A. Johnson, 99–181. Contribution of Working Group I to the Third Assessment Report of the Intergovernmental Panel on Climate Change. Cambridge: Cambridge University Press. https://www.ipcc.ch/site/assets/uploads/2018/03/TAR-02.pdf

Hickey, Joseph J., and Daniel W. Anderson. 1968. "Chlorinated Hydrocarbons and Eggshell Changes in Raptorial and Fish-Eating Birds." *Science* 162, no. 3850 (October 11): 271–273. https://doi.org/10.1126/science.162.3850.271

Hou, Loren, Caleb D. McMahan, Rae E. McNeish, Keenan Munno, Chelsea M. Rochman, and Timothy J. Hoellein. 2021. "A Fish Tale: A Century of Museum Specimens Reveal Increasing Microplastic Concentrations in Freshwater Fish." *Ecological Applications* 31, no. 5 (July 1): e02320. https://doi.org/10.1002/eap.2320

Huhtamaa, Heli. 2020. "The Good, Bad, Undefined Little Ice Age." *Historical Climatology*, June 3, 2020. https://www.historicalclimatology.com/features/the-good-bad-undefined-little-ice-age

Johnson, Steve. 2021. "Fish Guts on the Red Line: Chicagoan Was Transporting Specimens for a Study Showing the Long History of Microplastics in Freshwater Species." *Chicago Tribune*, May 6, 2021. https://www.chicagotribune.com/news/environment/ct-microplastics-fish-1950s-field-museum-study-20210506-rcmls47vwjehzho5gtabom7lpm-story.html

Lishawa, Shane C., David J. Treering, Lane M. Vail, Owen McKenna, Eric C. Grimm, and Nancy C. Tuchman. 2013. "Reconstructing Plant Invasions Using Historical Aerial Imagery and Pollen Core Analysis: *Typha* in the Laurentian Great Lakes." *Diversity and Distributions* 19, no. 1 (January): 14–28. https://doi.org/10.1111/j.1472-4642.2012.00929.x

Luterbacher, Jürg, Elena Xoplaki, Daniel Dietrich, Ralph Rickli, Jucundus Jacobeit, Christoph Beck, Dimitrios Gyalistras, Christoph Schmutz, and Heinz Wanner. 2002. "Reconstruction of Sea Level Pressure Fields over the Eastern North Atlantic and Europe Back to 1500." *Climate Dynamics* 18 (March): 545–561. https://doi.org/10.1007/s00382-001-0196-6

Mauelshagen, Franz. 2014. "Redefining Historical Climatology in the Anthropocene." *The Anthropocene Review* 1, no. 2 (June 27): 1–34. https://doi.org/10.1177/2053019614536145

Nic Lughadha, Eimear, Barnaby E. Walker, Cátia Canteiro, Helen Chadburn, Aaron P. Davis, Serene Hargreaves, Eve J. Lucas, et al. 2018. "The Use and Misuse of Herbarium Specimens in Evaluating Plant Extinction Risks." *Philosophical Transactions of the Royal Society B* 374, no. 1763 (November 19): 20170402. https://doi.org/10.1098/rstb.2017.0402

Oliviera, Gil, Eric Dorfman, Nicolas Kramar, Chase D. Mendenhall, and Nicole E. Heller. 2020. "The Anthropocene in Natural History Museums: A Productive Lens of Engagement." *Curator* 63, no. 3 (September 1): 333–351. https://doi.org/10.1111/cura.12374

Pfister, Christian, and Rudolf Brázdil. 2006. "Social Vulnerability to Climate in the 'Little Ice Age': An Example from Central Europe in the Early 1770s." *Climate of the Past* 2, no. 2 (April 7): 115–129. https://doi.org/10.5194/cp-2-115-2006

Pfister, Christian, Rudolf Brázdil, Barbara Obrebska-Starkel, Leszek Starkel, Raino Heino, and Hans von Storch. 2001. "Strides Made in Reconstructing Past Weather and Climate." *Eos, Transactions American Geophysical Union* 82, no. 22 (May 29): 248. https://doi.org/10.1029/01EO00141

Schmitt, C. Jonathan, Joseph A. Cook, Kelly R. Zamudio, and Scott V. Edwards. 2018. "Museum Specimens of Terrestrial Vertebrates are Sensitive Indicators of Environmental Change in the Anthropocene." *Philosophical Transactions of the Royal Society B* 374, no. 1763 (November 19): 20170387. https://doi.org/10.1098/rstb.2017.0387

Sigfúsdóttir, Ólöf Gerður. 2021. "Curatorial Research as Boundary Work." *Curator* 64, no. 3 (May 24): 421–438. https://doi.org/10.1111/cura.12417

Star, Susan Leigh, and James R. Griesemer. 1989. "Institutional Ecology, 'Translations' and Boundary Objects: Amateurs and Professionals in Berkely's Museum of Vertebrate Zoology, 1907-39." *Social Studies of Science* 19, no. 3 (August 1): 387–420. https://doi.org/10.1177/030631289019003001

Trouet, Valerie. 2020. *Tree Story: The History of the World Written in Rings*. Baltimore: Johns Hopkins University Press.

2

HOW HUMANITIES MATERIALS ARE PROXIES FOR DOCUMENTING CLIMATE CHANGE

"Dense populations and complex societies keep more written records, including trade, naval, and agricultural documents, explicit weather and nature observations, and census data" (Trouet 2020, 92). These are "man-made climate proxies …" (92). Some of them are instrumental records from barometers, thermometers, rain gauges, and compass readings. Some of them are documentaries from notes, images, drawings reports, and remembered oral communication. Both kinds are critically valuable to understanding change over time in any location or region. When combined and aligned with other proxy data, humanities-based or not, they can illustrate change over time. This change over time is the difference between *before and after:* before humans intensified fossil fuel use so significantly as to change the climate, and after this began and as it continues. The proxies can be the data found in the comparative size and frequency of glaciers 50 years ago and today; they may appear in oral histories that capture animal populations present decades ago but no longer available for hunting; and they are often found in cultural traditions based on natural resources no longer available. Humanities climate proxies illustrate changes in measured frequency, extent, scale, range, concentration, absence and appearance, loss, and damage, just as paleoclimate proxies do. Archaeological sites and their finds contain data signaling climate change that can add to or validate an existing climate model or record. That baseline data are necessary if we are "to develop temporal and spatial sequences, calibrate chronologies at all scales, and constrain absolutely dated materials or events" (St. Amand et al. 2020). There is confidence in the scientific use of proxy data for understanding climate change, and a growing recognition that climate historians can use historical humanities data to complement their instrumental data and scientific models of historical climates. Let's consider more closely how cultural heritage resources can expand the proxy data resources for understanding climate change.

DOI: 10.4324/9781003044765-3

To illustrate the breadth and variety of proxies, historical climatologist Franz Mauelshagen lists the merchant fleets of colonial powers, documentary information from Australian settlers from Europe, "governors' correspondences, early settlers' diaries and newspapers" (2014, 10). Ships' logs are frequently identified by researchers as extraordinarily valuable. These logs were kept regularly and precisely, certainly daily often hourly, given that wind direction and speed, the presence of ice, water conditions and currents, and precipitation helped inform future travels (and economic potential) while providing critical information for the safety of ships, cargo, and crew. Those who traveled the same route after would depend upon this reporting as they made decisions affecting the lives of the crew and the fortunes of owners. Their ships navigated oceans for four centuries before satellite-connected buoys relayed the modern comparative data we use to illustrate that change over time (Mauelshagen 2014).

Mauelshagen explains that documentary materials contain two overarching types of evidence: "direct observation of meteorological parameters (be it measured or not) and indirect observation of climatically influenced processes in nature (observed and natural proxies)" (2014, 7). Both are humans' observations of weather and climate documented in written form (e.g., diaries, logbooks, and planting notes), graphic form (e.g., paintings, drawings maps, and photographs), or narrative form (traditional knowledge through stories and recounting). Sometimes these direct observations include using instruments such as thermometers and barometers, or rain gauges to measure meteorological conditions. Sometimes these observations are noted by those experiencing the phenomenon or present at a place and time where an activity required regular notations, or a dramatic event captured their attention. These data are often mixtures of direct and/or indirect data with measurements and/or observations, from documentary and/or instrumental resources. For a museum professional examining materials as a potential proxy data source, it may be simpler and helpful to organize one's thinking through two frames: "timing" and "capture." Capture: do the records come from instrumental readings, physical evidence, or human observation? Timing: was the record created at a moment of measurement or observation, was it maintained over time such as in oral tradition, was it noticed and later recorded as in a painting or memory, or was it noticed later in physical evidence or through observation or interpretation? Time and capture help understand the data.

Researchers—both scientists and historians—are improving their understanding of these sources of information and ways to identify, combine, interpret, and verify them as historical climatology continues to advance. At present, climate information resources are most frequently identified and researched outside museums in government documentary records or data collections. Most of it is used primarily in academic circles for climate modeling far from the public's immediate use. And some materials are resting in our museums' collections, just waiting for us to notice and to share them.

We will begin by examining the instrumental record and academic circles, and then progress to documentary resources outside museum collections and within them. In these examples, there are notes when the researcher or the materials are

identified as at a museum. If there is no such note, these valuable resources are either outside a museum or the researcher has not identified the location or ownership. If some of these materials have been accessed through museums, the researcher has overlooked the institution's engagement or value in this work. Museums' contributions are important and worth documenting. If these research partnerships were celebrated and nurtured, everyone's work and story would be richer for it.

Documentary Climate Proxy Sources: Instrumental and Non-instrumental

Instrumental Proxy Data

Researchers are recreating climate history with proxy data (whether paleo or documentary) for two reasons: to identify when and how the climate has changed, and to understand how people may have adapted in the past to climate changes to improve our own adaptations. They are expanding documentary research to tell a more complete story on both topics, but this work remains an emerging practice.

In 2017, Professor Harvey Weiss of the Yale School of Environment convened a workshop focusing on societal adaptation to abrupt climate changes that have occurred before the 20th century's global warming. The participants examined six episodes of past climate change using instrumental and paleoclimate records, and archaeological and historical records. The subjects ranged in time from 2200 BC to the 19th century AD, and place from East Asia and North America, with their megadroughts, to Europe's Little Ice Age (Weiss 2017). Though the research motive was to improve understanding of societal adaptation to these events, in the process, the discussants described the role of proxies for documenting changes in the climate. That approach is transferrable to current research on global warming and the use of cultural climate proxies, including humanities documents and heritage resources.

The summary of the discussions reflects how anthropology's fieldwork approach and continuous research into the human–environmental relationship illustrate the alignment of paleoclimatology with historical climatology: both paths to understanding our past climate incorporate the study of natural systems affecting and affected by climate. The convening established how multiple data sources and research disciplines create a fuller picture of history and that this is necessary for studying climate history, whether the research question is an adaptation to change or evidence of change (Weiss 2017). These data sources may be instrumental records, documents of personal or commercial observations, and oral histories and traditional practices. Additions of historical climate records of all types will continue to build the case already made by these researchers. The examples that follow will focus not on data related to human adaptation, but on data to illustrate and understand the impacts and evidence of global climate change.

As historical climatology and the practice of climate modeling have improved and expanded, so has the hunt for data deemed reliable for expanding and improving this modeling. Access to instrumental data, the Western approach to measurement

and proxies, has been a stumbling block for the period before the development of networks of national and international weather stations. This affects the concepts of timing and capture, since the date of the advent of instrumentation marks the beginning of the availability of this type of resource for an area under consideration. Understanding the depth and breadth of instrumental data helps researchers understand where and how to build out collateral proxy data to create a fuller picture. To document and promote the availability of stationary data, including stationary ships at port (as opposed to moving data from logs made during sea travel), a team of 54 researchers, many already cited in this text so far, co-created a global inventory of early instrumental meteorological measurements, most pre-dating 1850. The authors selected 1850 as a cut-off year because "this approximately reflects the start of national weather services (e.g., Prussian Meteorological Institute: 1847; Smithsonian Institution network: 1849; weather service of the Austrian empire: 1851; French meteorological service at the Observatoire de Paris: 1855) …" (Brönnimann et al. 2019, ES392). The authors consider this as "the beginning of international standards" (ES392). The cut-off for regions such as Africa and the Arctic was set for 1890 to reflect the beginnings thereof instrumental measurements.

The inventory of sources began with digital data repositories, proceeded to national inventories of digital resources, then gathered community knowledge and non-digital inventories as well as early collections and networks (Brönnimann et al. 2019). Most of the resources identified are undigitized. The authors estimate that only 25% of the 4,583 non- and partial-duplicate listings are fully transcribed, and another 25% only partly (ES397). At least the material is identified, but clearly not yet fully accessible.

Their summary of that data opens with the statement "Climate data are part of our cultural heritage," but notably only one of the 54 authors is listed affiliated with a museum, the Royal Museum for Central Africa in Belgium (Brönnimann et al. 2020, 43). A separate list describes repositories searched and does mention the National Library of Iceland and the French National Archives, and the Smithsonian Institution, but most often the source is a national government agency.

The full inventory lists where the records were made, when, and by whom (capture and timing). The authors describe the resource types by region, which gives us a glimpse of the types of records with climate proxy data that may be waiting in museum collections. Europe has the most abundant, and the most widespread, entries in the inventory, with doctors, astronomers, and weather station observers among the most common recorders of instrumental data. In Africa, the data are from scientific expeditions, missionaries, pharmacists in military hospitals, colonial residents and administrators, cartographers, and botanists. In Asia, the sources are travelers, missionaries, consulate staff, newspapers, and military surgeons. In South America, "the main observers … were scientists, explorers and military personnel" (Brönnimann et al. 2019, ES399–400). In North America, Central America, and the Caribbean, the authors find that Joseph Henry's work for the Smithsonian is "one of the most important collections of historical climatic data for North America" (ES400). (More on that in Chapter 4 on public engagement potential

by museums.) The US Army Medical Department aggregated data during the War of 1812. Hudson Bay Company factors or traders captured data at their stations in the north and northwest of what became the USA and Canada. In the Southwest Pacific, colonial administrators kept records in settler cities and penal colonies. As the population expanded, residents in agricultural communities also kept records. The authors usually did not highlight where records are physically currently housed, only that "most historical inventories are nowadays largely forgotten," the authors write, "because the metadata from these inventories have never been digitized" (ES391).

In the USA, a report on the "Climate Change Indicators" web page of the Environmental Protection Agency (EPA, n.d.) is based on the form of instrumental data recording the springtime ice breakup at three Alaskan rivers, the Tanana, Yukon, and Kuskokwim, but does not note the home of these records. Each site has been monitored by local residents for decades, even more than a century. The breakup is celebrated in the community. The event signals the opening of the river for travel and for hunting and fishing or indicates potential ice jams and flooding. Understanding the timing of the breakup is of benefit to everyone, and the competition to guess it has become its own community event.

As informal bets grew more competitive and attracted more participants, the testing became more sophisticated. All three communities began recording the breakup when a clock on shore is stopped automatically by shifts in the ice as it moves or breaks. A cable runs from the clock to a tripod set on the ice. The report states that there are records for these breakups since 1896 in Dawson City, Canada, on the Yukon, in the USA in Nenana on the Tanana River since 1917, and in Bethel on the Kuskokwim River since 1924 (EPA, n.d.). An overlapping report on the impacts of climate change in the Canadian Yukon by Environment Canada mentions the record of ice-out change over time as an indicator of warming temperatures from a changing climate. Its authors write

> The exact timing of the ice breakup on the Yukon River in Dawson has been recorded every year since 1886. The practice that originated from a lively betting tradition now provides a long-term indication of how changes in climate are impacting the breakup.
>
> *(Research Northwest & Morrison Hershfield 2017, 9)*

The 120 years of records creates a trend line that "shows the spring breakup occurring on average 6 days earlier per century" (9).

This instrumental record, when the clock is stopped by the ice shift, is the basis for this measurement, but there is a more engaging story with the visual record of lottery tickets; the list of names with their choices, the winner's announcement, and perhaps her photograph in the paper as each year's story; and the sequence of winner's images, names, and dates over the years as the illustration of how we are witnessing climate change in our lives. Some of the researchers examining measured data are also capturing, or beginning to capture, these narratives that illustrate the climate change story more fully.

Instrumental Proxy Data with Narrative Proxy Data

Environment Canada has paper records of weather observations from 1840 to 1960, over a century. A steadily expanding network of weather observers stationed across the country had been gathering data over decades until the agency created an online National Climate Data and Information archive from its quantitative contents. The original narratives were not transferred despite containing so much collateral data. Fortunately, a historical climatologist, Alan MacEachern (2016) recognized such a treasure trove and managed its transfer to the University of Western Ontario. He and his students are examining the weather data records to understand how the observers' qualitative comments related to their quantitative data, and how these comments and measurements may reflect the weather in a region, impacts on farming, or descriptions of the impacts of extreme weather events more closely, than measurements alone. As an example, many of the records also note bloom times for orchards, an important indicator of weather conditions that can demonstrate changes in regional climates. Phenology, the study of natural cycles which includes the study of bloom times, benefits from the efforts of weather observers, botanists, birders, farmers, and diarists who have captured this data around the world and over centuries. These records can be found in isolation, such as the record of lilacs blooming in Washington, DC, on April 15, 1865, as noted by Walt Whitman (1865) in his poem mourning the death of President Abraham Lincoln, or they can be found across 12 centuries of bloom time records for Japan's nationally significant cherry trees (Primack et al. 2009). Researchers in museum collections can find such data to fill in gaps in the instrumental record and reinforce those records by confirming or completing them, while adding identifiable people to an equation, placing them and their experience of climate right at the center. This of course is where it should be, the Anthropocene is that geological epoch where humans leave their mark on the planet.

Building a Fuller Picture

History outside of the paleo record depends on historical and archaeological evidence, even ancient history to build a more complete picture of past contexts. Though the ancient period is outside of this book's focus on the Anthropocene, the period's literary materials of "poetry and prose, and from papyri and inscriptions" (Hughes 2014, 6) are examples of how environmental history has used them as proxy data for conditions. Hughes notes that

> Ancient Greek and Latin history, philosophy, drama, epic and lyric poetry, scientific and technical treatises, correspondence, and legal documents contain numerous references to environmental problems The richness of this line of evidence is not as well known as it should be
>
> *(6)*

Hughes attributes this to gaps in resources or resource-identification in major areas of the world, and sectors of society, and failure to recognize these resources.

Regarding gaps, he writes that one cause "is the simple lack of evidence for some periods and places, especially from early times and less urbanized areas." For example, for parts of Africa "systematic weather records" (Nash and Hannaford 2020, 42) are limited, including measured and narrative data (Brönnimann et al. 2019). Even where instrumentation had begun, there were gaps. A weather station might be abandoned or taken out of service. Conflicts and social unrest might disrupt reporting or publications, damage equipment, and interrupt communication lines. Whatever the reason, the instrumental records are incomplete in many aspects and regions, requiring the identification of new resources to provide a fuller picture locally, regionally, and globally. This is why multiproxy data use, collecting and combining a variety of data resources to illustrate and understand conditions, is so important and what makes documentary evidence so necessary (Diemberger et al. 2012, 240). The process is more complex and can be more time-consuming than solely using instrumental data, but it can yield enough information for recreating baseline conditions, and the variety of information necessary for building knowledge of localized climate experiences rather than global or regional climate experiences.

For this granularity, more varied resources are improving understanding. The rest of this chapter visits a variety of data sources to illustrate the breadth of material appropriate for this work and the processes used to select and verify the data.

Mixed Proxy Data

Ships' Logbooks

The New Bedford Whaling Museum has a significant collection of whaling logbooks. Professor Timothy Walker at the University of Massachusetts Dartmouth and Caroline Ummenhofer from the Woods Hole Oceanographic Institution are using the information in those pages to fill in gaps in weather information as it contributes to climate science. The logbooks are the formal record of the ships' travels. They use a mix of instrumental records and personal observations. The sailors responsible for this record regularly noted ships' location, rainfall, clouds, ocean currents, wind speed and direction, and of course sightings of whales. Of particular interest are the wind patterns noted on ships' journeys. For pre-satellite days, how else can a researcher develop a baseline comparison to understand the wind patterns over the oceans in the 19th century and more recent ones? What they're learning is that "in the past 30 to 40 years, the same winds the New England whalers used to travel across the Indian and Southern Oceans have migrated ten degrees in latitude to the South Pole" (Chanatry 2021). This shift, attributed to a changing climate, is affecting wind patterns in many parts of the world. The changes in the winds affect the conditions on land in Western Australia and South Africa, contributing to drought conditions there "in part because the prevailing winds now carry much of the rain too far south to make landfall" (Chanatry, 2021).

Non-instrumental Proxy Data

Municipal Records

To uncover climate change over a longer period, researchers must be able to recognize variabilities and understand if they reflect changes in weather or changes in climate. Changes in weather are experienced on a short-term basis and can be described as the temporary experience of conditions around a person or a community. Changes in climate are more widespread, affecting larger geographical areas and lasting longer than a few seasons and even a few years, but they do influence variations locally. Being able to distinguish between climate-driven variabilities locally and globally, and those changes that reflect more limited conditions is a difficulty in using proxies for research, but interpretive methods continue to improve. The example of researchers examining municipal documents of small towns in southern Spain from the 17th to the 20th century showcases three methods of research. It also highlights how to recognize and understand valuable climate data in local materials.

The documentation was the written record of Municipal Chapter Acts (MCA) in small towns where councillors and mayors held frequent meetings for purposes of managing the town. Across the region, careful records were kept of these meetings. Weather and its effects on crops were just such an issue. The researchers analyzed this record set using three approaches and compared the results to test accuracy. The first method coded and recorded steps in and frequency of rogations or when community members petitioned the church to hold a rogation to ask God to either send or stop the rain. The procedures for rogations are "strictly regulated by the Vatican" (Gil-Guirado et al. 2019, 1308) and therefore can be relied upon for consistency. Such a request was only made if the conditions were so substantial as to drive sufficient people to petition the church for, and participate in, the masses, processions, or pilgrimages to ask God for this intervention. These calls represent a widespread acknowledgment of conditions, making their documentation a very dependable assessment of conditions in a locale; a single observer's report would require additional corroboration to be equally strong evidence (Gil-Guirado et al. 2019). The second method of content analysis is a tested but relatively new coding technique for frequency and intensity of terms used to describe weather conditions, often as they affect agriculture and travel. The third approach tested the hypothesis that the volume of sealed paper used to describe weather events reflected the intensity and duration of the climate event since the actual paper used to record these discussions was expensive, and a less important or unimportant issue would have not been worth using such expensive paper to note. Sealed paper was an expensive material demarked by the royal seal and required for municipal records.

The results from using each of the three research methods had some variations but the alignments were so significant that each was designated valuable for processing large amounts of documentary material in reliable ways. "The richness of worldwide documentary heritage," conclude the authors, "calls for new

methodologies to be developed to overcome such methodological limitations by allowing new high-resolution multisecular reconstructions to be done" (Gil-Guirado et al. 2019, 1328).

Archaeological Collections

"Legacy collections," the previously excavated archaeological materials in museum collections warrant revisiting for proxy data. Eight researchers, three of them from museums, made a case for reassessing these legacy archaeological collections to yield more data, particularly new paleo and historical information as researchers re-examine materials or their origin sites. Sometimes the sites of the collection have been lost to building development or new land uses, or to the impacts of climate change such as shoreline erosion, melting permafrost and ice, sea-level rise, or fire (St. Amand et al. 2020). This means the collections are the only extant resources left. The case for re-examining these legacy collections holds true for identifying climate change over the last century. There may be historical data that predate the Anthropocene and can serve as a benchmark, a baseline. Materials where wood items have survived provide tree ring data, as already discussed, that can help set dates and establish natural resource availability at that time. There may be pollen present or evidence of food sources. If those differ from what would be found in those places today, a researcher can explore if the cause of the change was development, environmental change or damage, or anthropogenic climate change. The notes from the original digs may have evidence as well: Do the site drawings illustrate a different shoreline level now than historically? Is this due to site use, or site exposure due to climate change such as erosion? Or is it the result of climate changes such as fire or storms and sea-level rise? Is the area's vegetation the same or has it changed for those same reasons? Legacy archaeological collections contain not only the paleo and historical data collected from the site, but also the historical data from the archaeologists' own records and reports.

Wooden Materials

The wooden elements found at a dig site or in fallen trees of the landscape; and in historical objects such as coffins and furniture; and in the timbers of tunnels or underground dwellings and food caches; all offer a piece of the climate record. This is not new knowledge for the museum sector; historians have been using dendroarchaeology to date buildings for nearly a century (Hayward 2018). But like legacy archaeological collections, these historic materials are also a pool of climate change data awaiting re-examination in every museum collection and at every historic site. The data can provide a baseline record (what trees were growing under what conditions, where, and when), a climate impact record (when a series indicates an impact associated with events attributed to climate (i.e., storms [Trouet 2020, 105] and avalanches and fire), or it may document a whole record of changes within the lifespan of the tree established before anthropogenic climate change and still living today.

Images and Depictions: Photographs, Paintings, Drawings, and Prints

Because anthropogenic climate change has been most dramatically evident during the last three-quarters of a century, images from before this period can provide comparisons of change over time when paired with an image from and of the same location decades or a century since. The changes to two famous glaciers in the Swiss Alps show how documentary evidence can illustrate the impacts of a changing climate. Historically some portions of the Lower Grindelwald Glacier and Mer de Glace Glacier reached far into habituated valleys during the 16th and again in the 19th centuries. In the late 19th century and early 20th century, they had become tourist destinations, accessible by train and popularized by images in paintings, drawings, prints, maps, and photographs. These images illustrate the glaciers' reach, scale, and change, over time. This makes it possible to verify the historical extent of the glaciers with confidence and then compare the examples with current data. The authors state that these images, "compared with today's situations, [illustrate] … totally different landscapes – a comparison of [Little Ice Age] images with the same views of today is probably the best visual proof for the change in climate" (Zumbühl and Nussbaumer 2018, 115). For transparency in the research and to establish the reliability of using such images for documentation, the authors described their criteria for interpreting the materials consistently and in a manner that other researchers could duplicate. This meant confirming the date of the "depicted scene" (if it was a painting completed within weeks or at a later date or a photograph as a real-time capture); selecting an image with a clear representation of the physical aspects of glacier and surrounding topography; and confirming the location of the artist or photographer's "viewing position" as deduced from multiple features appearing in the image and possibly corroborated from artist documentation for the work.

The advent of photography as a public pursuit and the availability of trains into the Alps and near the two glaciers meant a significant increase in visibility that benefits present-day research through a great deal of written and pictorial documentation. Research on the Mer de Glace glacier benefits from almost a surfeit of documentary evidence. There are travel accounts and drawings, paintings, and prints by multiple artists beginning in 1770. Starting in the mid-1850s, the glacier began a rapid retreat that was well documented by photographs. And since 1878 there have been continuous measurements of the glacier's front position. Just from 1995 until 2015 it has retreated by 728 meters or nearly a half mile. The Lower Grindelwald Glacier has been similarly extensively documented, and since 1855 has experienced "a nearly continuous loss of ice … about 32–41% of its length … and about half of its volume" (Zumbühl and Nussbaumer 2018, 122). The examination of centuries of materials documents that both glaciers experienced significant expansions during what is known as the Little Ice Age, a phenomenon experienced most significantly in Europe and lasting into the third quarter of the 18th century. Since that time, the glaciers have either been stable or in retreat, with retreat beginning to be continuous in the 1930s and "especially impressive after 1995" (115). These retreats are strong signals of a warming climate. These glaciers were

important in daily life for this region: both often reached quite close to villages, occasionally forcing abandonment of a home or homes. As a result of this popularity and familiarity, and of documentary and visual evidence resulting from tourism, there is very strong confidence in the conclusions of a changing climate developed using this visual evidence of period images and historical maps to modern aerial photography as proxy data.

But a word of caution about the study of glaciers during this period. As the authors explain, the warming of the average temperature of the Earth's atmosphere and oceans since the advent of fossil fuels has led to dramatically accelerated glacial melting as demonstrated in these images. There is, however, a frequent uninformed public comment that the Little Ice Age as experienced in Europe is an example of how climate change is a natural phenomenon, suggesting that its example is evidence that present climate changes are similarly natural. Though the Little Ice Age was not triggered by humans, it is not correct to infer that therefore present-day climate change is likely to be naturally occurring. This is a misinterpretation of the evidence. Museums and their research peers can easily address this by demonstrating how these collections materials demonstrate climate changes, that burning fossil fuel has increased the greenhouse gases that warm the atmosphere and can be detected using collections materials, and that the resulting changes have never, ever been experienced at such a rate or scale.

The Anchorage Museum has similarly valuable documentation of climate change and from the Anthropocene. The signal is so strongly pervasive among the photographic materials that the staff has created a Climate Change Photography Resource Guide (Berman 2018). It helps researchers looking for photographic and archival materials in the Ward Wells Collection at the Museum that demonstrate a changing climate. The guide has a description of the resources, instructions on using the guide, descriptions of seven categories of materials within the collection "that can show climate change," and the lists of materials in that section. The guide demonstrates the author's understanding of climate change, the collection, and its potential uses. The approach is similar to the use of the early images and depictions of the Lower Grindelwald and Mer de Glace glaciers to illustrate change over time when compared to modern images or measurements. As the author explains in the Guide's introduction, "Using photographs and photographic negatives as primary source materials for the study of climate change, one can see the difference between the landscape of Alaska in the past and the present. Photographs capture specific moments in time, making these images important resources to demonstrate climate change prior to official scientific measurement" (1). In the section on "ice," there are images of "glaciers, sea ice, and other ice conditions" (3) from the 1950s to the 1970s. Some are of the Mendenhall Glacier. The guide explains that the glacier's retreat over the last 30 years has meant that at the end of the 21st century, visitors may no longer be able to view the glacier from the US Forest Service's visitor center built for that purpose in 1962. It would have retreated out of sight. Already the Portage Glacier, so popular with tourists, is no longer accessible by land, "now only accessible by boat due to how far back it has receded" (5).

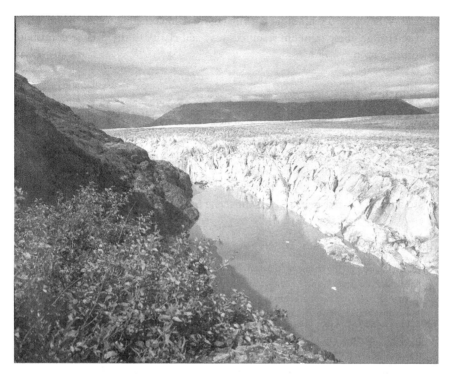

FIGURE 2.1 Ward Wells Collection, Anchorage Museum, B1983.91.S118.R1. Knik Glacier before break up, undated. "Perhaps best known as the filming location for the 1991 film, Star Trek VI: The Undiscovered Country, Knik Glacier has receded in recent years, causing a lake to form in front of it" (Berman 2018).

The guide includes image resources that do not focus on ice and yet may be useful for identifying the physical impacts of climate change in the future. Just as the legacy notes from archaeological digs are baselines for comparative changes over time, images of infrastructure such as roads, bridges, and airport landing strips can be baselines for comparison when later they are damaged by climate change. The impacts may be identifiable by comparing historical photographs of infrastructure locations and conditions, and current or future conditions and damage. This includes buckling due to melting permafrost caused by warming temperatures, erosion and breakups caused by storm events, and resulting flooding from surface water or shoreline loss resulting from rivers no longer armored with permafrost or ocean shorelines no longer protected by sea ice during winter storms. The comparison of only a few decades' time can illustrate loss and damage from climate change.

Similarly, images in the Wells collection depicting plant life and landscapes record existing specimens and their conditions at times in the 1950s through the 1970s. Tree species included are described as spruce, dogwoods, dwarf dogwoods, pussy willow, and birch. Flower species are identified as wild orchids, geranium and columbine, and iris and violets. This is a baseline. A comparative sampling of those sites and plants today and in the future may help document responses to a changing

climate. When paired with other data in a more complete time series documenting climate change, these museum resources may add clarity to the data or contribute to corroboration.

Conclusion

These are clear examples of how cultural heritage materials can be examined for evidence of climate change. Some are from museums. This is emerging work; there is still much more to learn about how to improve the interpretation of and access to this information whether it is found in museums or cultural heritage materials. Chapter 3 explores what researchers are learning that will help cultural heritage professionals to use this data for research, and sets the scene for Chapter 4 on public engagement.

References

Berman, Claire. 2018. *Climate Change Photography Resource Guide*. Anchorage, Alaska: Atwood Resource Center, Anchorage Museum. https://www.anchoragemuseum.org/media/12164/climatechangeguide.pdf

Brönnimann, Stefan, Rob Allan, Linden Ashcroft, Saba Baer, Mariano Barriendos, Rudolf Brázdil, Yuri Brugnara, et al. 2019. "Unlocking Pre-1850 Instrumental Meteorological Records: A Global Inventory." *Bulletin of the American Meteorological Society* 100, no. 12 (December 1): ES389–ES413. https://doi.org/10.1175/BAMS-D-19-0040.1

Brönnimann, Stefan, Rob Allan, Linden Ashcroft, Saba Baer, Mariano Barriendos, Rudolf Brázdil, Yuri Brugnara, et al. 2020. "Instrumental Meteorological Records Before 1850: An Inventory." *Bulletin of the American Meteorological Society* 101, no. 1 (January 1): 43–47. https://doi.org/10.1175/BAMS-D-19-0040.A

Chanatry, Hannah. 2021. "19th Century New England Whaling Logs Offer Clues to 21st Century Climate Change." WBUR News, November 29, 2021. https://www.wbur.org/news/2021/11/29/new-england-whaling-logs-indian-southern-ocean

Diemberger, Hildegard, Kirsten Hastrup, Simon Schaffer, Charles F. Kennel, David Sneath, Michael Bravo, Hans-F. Graf, et al. 2012. "Communicating Climate Knowledge: Proxies, Processes, Politics." *Current Anthropology* 53, no. 2 (April): 226–242. https://doi.org/10.1086/665033

Environmental Protection Agency. n.d. "Community Connection: Ice Breakup in Three Alaskan Rivers." *Climate Change Indicators in the United States*. Accessed December 30, 2021. https://www.epa.gov/climate-indicators/alaskan-rivers

Gil-Guirado, Salvador, Juan José Gómez-Navarro, and Juan Pedro Montávez. 2019. "The Weather behind Words – New Methodologies for Integrated Hydrometeorological Reconstruction through Documentary Sources." *Climate of the Past* 15, no. 4 (July 10): 1303–1325. https://doi.org/10.5194/cp-15-1303-2019

Hayward, Judy. 2018. "Dendrochronology: William Flynt Brings Science to New England's Historic Buildings with Dendrochronology." *Traditional Buildings*, April 11, 2018. https://www.traditionalbuilding.com/product-report/dendrochronology

Hughes, J. Donald. 2014. *Environmental Problems of the Greeks and Romans: Ecology in the Ancient Mediterranean*. 2nd ed. Baltimore: Johns Hopkins University Press.

MacEachern, Alan. 2016. "Clio and Climate: On Saving and Researching a Climate History Archive." *Historical Climatology*, May 16, 2016. http://www.historicalclimatology.com/features/clio-and-climate-on-saving-and-researching-a-climate-history-archive

Mauelshagen, Franz. 2014. "Redefining Historical Climatology in the Anthropocene." *The Anthropocene Review* 1, no. 2 (June 27): 1–34. https://doi.org/10.1177/2053019614536145

Nash, David J., and Matthew J. Hannaford. 2020. "Historical Climatology in Africa: A State of the Art." *Past Global Changes Magazine* 28, no. 2 (November): 42–43. https://doi.org/10.22498/pages.28.2.42

Newell, Jennifer, Libby Robin, and Kirsten Wehner, eds. 2017. *Curating the Future: Museums, Communities and Climate Change.* London: Routledge.

Primack, Richard B., Hiroyoshi Higuchi, and Abraham J. Miller-Rushing. 2009. "The Impact of Climate Change on Cherry Trees and Other Species in Japan." *Biological Conservation* 142, no. 9 (September): 1943–1949. https://doi.org/10.1016/j.biocon.2009.03.016

Research Northwest & Morrison Hershfield. 2017. *Yukon 'State of Play': Analysis of Climate Change Impacts and Adaptation.* Commissioned report. Yukon, Canada: Environment Yukon's Climate Change Secretariat. https://yukon.ca/sites/yukon.ca/files/env/env-yukon-state-play-analysis-climate-change-impacts-adaptation.pdf

St. Amand, Frankie, S. Terry Childs, Elizabeth J. Reitz, Sky Heller, Bonnie Newsom, Torben C. Rick, Daniel H. Sandweiss, and Ryan Wheeler. 2020. "Leveraging Legacy Archaeological Collections as Proxies for Climate and Environmental Research." *Proceedings of the National Academy of Sciences* 117, no. 15 (April 14): 8287–8294. https://doi.org/10.1073/pnas.1914154117

Trouet, Valerie. 2020. *Tree Story: The History of the World Written in Rings.* Baltimore: Johns Hopkins University Press.

Weiss, Harvey. 2017. "Collapse! What Collapse? Societal Adaptations to Abrupt Climate Changes before Global Warming." Yale University, Humanities Workshop proceedings, October 20–22, 2017. Accessed September 25, 2021. https://whc.yale.edu/sites/default/files/files/Collapse!WhatCollapse%20workshop1(1).pdf

Whitman, Walt. 1865-6. "When Lilacs Last in the Door-Yard Bloom'd." In *Sequel to Drum-Taps.* Washington, DC. Digitized and transcribed by The Walt Whitman Archive. https://whitmanarchive.org/published/other/DrumTapsSequel.html#leaf042r1

Zumbühl, H.J., and S.U. Nussbaumer. 2018. "Little Ice Age Glacier History of the Central and Western Alps from Pictorial Documents." *Cuadernos de Investigación Geográfica* 44, no. 1 (February 20): 115–136. https://doi.org/10.18172/cig.3363

3

BASIC DOCUMENTARY PROXY MATERIALS IN MUSEUMS

In all research, with all sources and conditions, a more complete picture is a stronger context for understanding, and researchers must be careful to build enough knowledge and context. The science is the foundation for understanding global change, but documentary evidence provides detail, color, and nuances not found in instrumental data or graphs. These data also contain some uncertainties not found in instrumental data and natural archives. There are many cautions for handling this data in a manner that identifies influences and improves accuracy, just as there are protocols for handling scientific information. We are all learning to use and interpret documentary data in that wider climate story.

Reasonable Use and Expectations of the Data

To increase the use and reliability of documentary resources as proxy data, the researcher must take care to recognize its current advantages and disadvantages compared to instrumental data. Instrumental measurements from well-calibrated and accurate implements, and the physical record of paleo or archaeological samples can be more specific, inert, and reliably comparable across larger datasets than human-generated records are likely to be, but there are verified methods of aggregating documentary data and using it quantitatively, through indexing and calibrating which build its value as evidence. With so many variables, the researcher must learn to recognize how they influence the availability of data, its contents, and its relatability to climate research. These include, but are not limited to quantity, fluctuations, influences, and accuracy.

Quantity

Whatever the data source, its use requires sufficient sampling to draw reliable conclusions anchored in the physical science of climate and the biological science of

DOI: 10.4324/9781003044765-4

ecosystems, even as we examine the social, economic, and political systems that affect the data (Pfister et al. 2008, 8). Data captured by people rather than instruments can be predominantly qualitative rather than quantitative. They are often available in smaller amounts and among distributed accounts, meaning fewer records and more locations to work with. This means it may be more challenging to locate and build a sufficient dataset than with instrumental data and are likely to be complementary and corroborative rather than sufficient evidence. But that does not have to remain the case. The examples in Chapter 4 for crowdsourcing documentary data for climate change research indicate a great change in data availability in the next few years. Museums are primed to use that approach to unlocking their own collections while contributing to climate change understanding.

Fluctuations

Fluctuations can occur as changes in time period, observers, place, and/or recording method. One reason is time scale or length of time series. For documentary proxies, the observer changes more frequently over time than a particular instrument or technology may for instrumental data. The period of pre-1850s until today, for example, spans longer than the lives of the observers, while an instrumental approach can span nearly that period, potentially providing more data and consistency. Within the life of the observer, there may be changes as well. The recorder may travel away from the measurement point, get sick and not be able to take measurements for a period, or change the frequency of measurements. She may change the time of day when recording the weather, or change or move instruments. Any of these may sufficiently shift averages and trendlines in numerical or graphical reporting (Stager et al. 2009, 15).

Accurate dating of the record is critical in research that compares change over time. Whether the date of record is captured by the author or interpreted by the researcher, the practices of the time and place are critical. It may be a record started at one point and finished at another, such as an artist's sketch onsite transformed later in the studio into a painting. The method of recording at the moment of capture may not be used later on, such as when the Gregorian calendar and modern dating use different timeframes (Pfister et al. 2008, 7).

Languages and language use are also changeable. Languages may evolve over the period of record and are different from region to region. Their modern interpretation may be complicated by formal and informal word use, style of the author, and the quality and style of handwriting or the copy method (7). Use in a working language may vary such as when notetakers for map-making use interchangeable common names for vegetation, or substitute common names for specific scientific ones (Kenyon 2015, 8–9).

Influences and Accuracy

Recognizing influences and understanding and improving accuracy is also a significant challenge in working with these documents for climate change research. Then

there is the challenge of understanding researcher biases *and* observer/collector biases when examining collections. Establishing historical context and interpreting the data record can help identify research biases. But understanding and interpreting the topics of both environment and climate is critical, too. This includes a learning curve for the researcher in both historical and present climate contexts.

First, let's look at biases and context; then let's distinguish between "environment" and "climate," and last, we'll examine how context and the influences of certain kinds of "noise" in the data can complicate discovery.

Researcher Bias

Researcher biases tend to cluster around enthusiasm which leads to confirmation bias, and culture which leads to social bias. Information limitations such as language and availability also lead to confirmation bias. For any researcher, it is exciting to find material that reflects the wider story they wish to tell. The urgency of addressing the climate crisis creates enthusiasm for finding, and pressure to find, potential solutions. Clues that support a hypothesis or interest may be selected or emphasized over contradictory ones. The reader may find climate data where there are only environmental data, as was nearly the case with the fishing journal research described later.

With the currently limited access to these data, it is easy and convenient to select one data point or a few to illustrate a finding, creating an availability bias in the conclusions. Increased digitization of these materials will help mitigate this, as may the improved awareness of collections managers and curators that their resources hold climate clues. However, sometimes the appearance of a lack of resources can instead be attributed to myopia on the part of researchers. These oversights occur in archaeology because professionals historically favored art and architectural finds over ecological ones in their research and collection (Hughes 2014, 6). Language barriers can create the same illusion when English-only researchers overlook resources. For example, during the 19th century, Hawaiian language newspapers were repositories of news but also academic discourse, much of it "a conscious effort to preserve oral traditions and conserve knowledge as foreign diseases and cultural change rapidly reduced the numbers of experts and elders who held this knowledge" (Businger et al. 2018, 140). Hawaiian knowledge of historic hurricane activity was overlooked because of the scarcity of language speakers able to interpret the historic record available in Hawaiian language newspapers. The situation was exacerbated by Western European misconceptions about what would be contained in those papers (Businger et al. 2018). (See more of this story in Chapter 6.)

Traditional Ecological Knowledge (TEK) and Indigenous Traditional Knowledge (ITK) are only recently becoming appreciated in the climate change communication and research domains. Historically there has been a very strong social bias in western research methods against ITK and TEK despite the capacity of Indigenous peoples to recognize climate change based on these societies' lived experiences and continuous knowledge. This bias continues today (Belfer et al. 2017, 67).

Climate researchers are broadening their acknowledgment of the types of historical resources important in understanding and interpreting climate change to thought-fully blend western science approaches and TEK and ITK. These resources are alive in the people, their communities, and their places. They are also alive in museum collections but separated from their communities; some by permission but most not. This makes their use different from westernized collections resources. TEK and ITK approaches recognize "nested knowledge systems (information–practices–worldviews) …. This knowledge includes local natural resource management, soci-ocultural governance structures, social norms, spiritual beliefs" (Nalau et al. 2018, 851) that together may include climate signals that a cultural heritage approach can sufficiently recognize but a western scientific approach may not. However, there is also a recognition that western researchers acknowledging the value of these knowledge systems must be careful to avoid "a blanket approach where any ITK is included" (860). There are situations where the ITK has been recognized as critical knowledge for understanding and interacting with a place, region, or phenomenon, but the conditions for its application have changed so significantly that is no longer aligned with current circumstances; ITK "might be misleading or not able to keep up with the changing climate" (860). The knowledge has long helped communities deal with weather events and disasters, but it is "no longer wholly sufficient" (859). "Given climate change, we need to better understand which parts of ITK remain relevant (e.g., early warning indicators or plant indicators for harvests and ceremo-nies) and where these are changing" (861).

Observer and Collector Biases

The attitudes and situation of the data observer or the specimen collector can influ-ence the presence, absence, and reporting of proxy data. For our purposes, the observer is the person making the documentary record, for example, the missionary, First Mate, the farmer, or the newspaper reporter. The collector is the person who captured the butterfly specimens, purchased the reed baskets, or built a library of his-toric diaries. Each has made their notes or acquired the resources in a way that can influence how researchers interact with the data and connect it to a larger picture.

For example, any collector is subject to personal biases of interest. Those who keep journals or travel diaries, or write to friends and families, record the instances of greatest interest to them, or experiences that are distinctive or extreme, and mate-rials that are exotic or rare. Certainly, personal preference may be obvious in a sin-gle-focus collection that has many examples of a single species that is not related to natural environmental conditions. The collector's personal interest may demonstrate confirmation, availability, and cultural biases as well as social, scientific, or political bias. It can all be reflected in their documentation. This is where historians' under-standing of the individual's personal context is so valuable to the overall research.

As an example, in natural history collections, researchers must be aware that insect collectors may have used an approach that was "opportunistic … rather than [aimed at] long-term monitoring of particular sites" (Kharouba et al. 2018, 2).

This bias, however, can be an advantage for a researcher by creating a treasure trove. Lepidoptera, or butterflies and moths, could be considered the charismatic megafauna of the insect world. Their beauty in behavior and appearance has had strong appeal worldwide for collectors from the Victorian era to today. This has provided a long and broad time series of specimens, specifically a group for whom seasonal timing—for food and migration—is specific, and therefore sensitive to changes. As a result, they likely generate highly detectable indicators of changes in the climate system. As the climate changes, systems nested within it are becoming, or are likely to become, out of sync: their timing is off, connections are missed, and components are out of balance. These disruptions are one of the cascading effects of climate change. For predicting the impacts of a changed climate, climatologists are identifying and modeling the potential for various impacts as the climate continues to change. Plants depend upon insects for pollination, and insects depend upon plants for food. The bloom time for the plant is a key element of this relationship. When changing temperatures affect a plant's lifecycle and its bloom time, it may be found to bloom when the insects are not available to pollinate it. Scientists call this phenological asynchronies. This miss limits fruit-setting for the plant and food sources for the pollinating insect and then other species. The scientists hope to understand the likelihood of this asynchronicity to anticipate ecosystem impacts from climate, and perhaps mitigate them. Much of the work of Primack and Miller-Rushing explored included understanding this mismatch using the baseline information from Thoreau and others in Concord (introduced below). Similarly, a study of collections records for 48,000 Canadian butterflies and another of 83,500 British butterflies have been important in documenting the reliability of the species' movements as indicators, and for concluding just where the degrees of risk for synchronicity are highest due to climate change, putting pollinators and food sources out of alignment in a manner dangerous to survival for both (Meineke and Jonathan Davies 2018, 3).

Observer and Collector Context

The context for the data creation or collection influences how and what is recorded or captured. Explorers' records are interesting and exciting snapshots of conditions, but alone they are not enough. Climate researchers note that explorers' "series are short because they changed their observation locations frequently. They used portable instruments, sometimes with poor calibration processes" (Brönnimann et al. 2019, ES400). Combined with other related data, though, explorers' records can be useful if there is enough detail. The original notebooks may have more information, for example, than an expedition's printed report which summarized data rather than spend hundreds of pages on tables.

Travelers' records may exhibit biases developed through the observer's own inexperience and social biases. These are influences in the data the researcher must understand and incorporate during this research. For example, if they were writing about Africa during the early 19th century, and their records are currently available,

then they were likely born in western Europe, and possibly visiting the continent for the first time, with little local context for recoding what they experience. As a result, "it wouldn't be at all surprising if they found southern Africa significantly drier than home" (Nash 2018).

In some data types, there are measures that create more uniformity and reliability. For the development of the Climatological Database for the World's Oceans: 1750–1850 (CLIWOC), 6000 logbooks from Hudson Bay Company ships provided data from voyages (Veale et al. 2017). The researchers noted that "the 'inherent homogeneity' of logbook entries allows for the original data to be presented in 'index' form on an ordinal scale" (4). There are 140,000 digital images from 4000 East India Company ships' logbooks now accessible through the US National Oceanic and Atmospheric Administration's (NOAA) National Climatic Data Center, with more being added from whaling ships and the US Navy and Coast Guard voyages in the Arctic. These, too, are noted for adherence to a basic standard that makes comparing information easier and more reliable, but the nuances of human recording still peek through as illegible handwriting or a recorder's chosen abbreviations (4). Climate researchers surely build their skills in deciphering just as any researcher must.

Weather Noise

The weather is what we experience today or this week or this season, outside the window and in our community. It's what the atmosphere brings today. It is what the diarist or farmer or newspaper records daily. The climate is a general trend in the atmosphere over longer periods of time, requiring more data and more perspectives to establish and verify. So, a long hot summer in one year is weather until it is part of a series of long hot summers. Weather may be noise (Huhtamaa 2020) in a climate study if a period is too short or the data points in it are too few. It may not be noise if that is the focus of the study.

For this study of how to illustrate changes in climate that have been induced by human behavior, that longer period is measured from the 1850s until now. Therefore, building the documentary database is important. When collected, these resources highlight trends that build an understanding of climate. When concentrated regionally, they highlight regional extremes that are otherwise smoothed out in a larger trend study.

Extreme events can be evidence of climate change or not, but they are often what is recorded. Extremes are something likely to be noticed. They are remarkable, unusual, and surprising. This unexpectedness or difference from all else may bias observers' reporting. Understanding the purpose of their documentation may help. Is it to note only the remarkable? A traveler or visitor while changing location may notice and record the weather when it is either distinctively appealing or difficult, and comment on it in relation to her activity of moving from one place to another. Diarists may only occasionally note weather, but most will likely include those extreme events which are remarkable. This means that dramatic or surprising

events may be remarked upon in documents far more than smaller, daily, expected occurrences, leaving the researcher with only data on extreme events rather than the mundane. However, a farmer is interested in the nuances of temperature, sunshine, rainfall, wind, etc. She is likely to record the detailed data daily and in one location because each factor may affect her crops which are either her livelihood or food source, or both. To her, both the extreme and mundane are important.

Noise in data depends upon what the researcher is pursuing. Just as a gardener would consider a plant in the wrong place to be a weed, whether or not it is technically a weed rather than unwanted, extremes of weather noted in diaries are not noise if the research focus is how experiences of past weather events and humans' interactions with them may be tools for planning responses to future climate-driven events and adaptation to a changed climate. In a study of databases of extreme weather, a collection called TEMPEST, includes a published chronology created by Edward Joseph Lowe (1870) and covering the years 220 to 1753 using "information from parish registers, county histories, periodicals and newspapers" (Veale et al. 2017, 3). The database's focus on extreme weather helps the researchers pursue the "understanding the nature of the events that might take place in the future" using "the construction of regionally specific climatic histories and historical extreme weather events, and investigations of the memories of and social responses to these events are crucial" (6).

Sampling

In a scientific study, sampling water, air, or materials is usually done with an instrument. When there are significant historical records, especially but too-rarely digitized, the researcher can sample the collection by studying the overall contents and then making a strategic selection of representative materials for study.

An important example is the work of Richard Primack and Abe Miller-Rushing in Concord, Massachusetts. For 13 years, between 1845 and 1858, Thoreau "made detailed observations of local flora and fauna" in Concord, Massachusetts, including Walden Pond. Richard Primack and his work with Abe Miller-Rushing and decades of students in Boston examined deeply how the documentary data from Henry David Thoreau, and other Concord chroniclers in the 160 years since, have created datasets that not only demonstrate the climate science, but tell a much more relatable story. Let's go back to Primack and Miller-Rushing's study of how to document climate changes using historical records. Thoreau captured the arrival dates of migrating birds to the region during the 1850s (this record lives at the Museum of Comparative Zoology at Harvard University). William Brewster and Ludlow Griscom's early 20th-century records of bird arrivals are kept at the Harvard University Library and Peabody Essex Museum, respectively. Both Brewster and Griscom were the curator of birds at Harvard University and held various roles at the American Ornithologist's Union and the Nuttall Ornithological Club. These resources provided baseline comparisons along with Thoreau's for studying bird arrival, as did those of Concord resident Rosita Corey from 1956–1973 to

1988–2007. Across all four datasets, 22 species appeared sufficiently for use in comparing data. The results did not give a clear demonstration of climate change in the manner that ice-out or bloom time has in other studies.

This is because of the different *systems* that produce the phenomenon recorded in these data (Primack 2014). Plants' ecosystems are less dynamic than that of migratory birds. The plants are stationery, and their nutrients are either present in the surrounding ground or brought to them through wind, rain, and sun. Birds can move to find alternative weather conditions and pursue food sources. Conditions can change due to shifting weather patterns, migrating or wind-blown insects, weather damage to seeds and fruits, or an overabundance of them. Each of these can influence when a bird begins a migration, where the destination is, and how quickly she reaches it. This ultimately influences arrival times at the migration's end. Primack and Miller-Rushing (2012) concluded "that the phenology of bird species was less responsive to the effects of climate than was the phenology of plant species ..." (177) and that the rate of change in arrival dates was related to the distance of migration. They also concluded, based on continued work and comparative research publications, that among the methods of sampling (bird arrival), sightings, bird calls, or capture in mist nets, created differing results, demonstrating that there is a "need to be mindful of the sampling methods used in previous studies when combining historical data sets or repeating historical observation" (177).

And yet, both scientific and historic researchers also find their samples by chance, not by intent. Primack was working for years before being alerted to Thoreau's material and then to Hosmer's. This happens regularly with historical collections because they contain data where we may not think to look for it. Consider the farmer's almanacs. Today they are generally not regarded as reliable indicators of true conditions. Historically they were the best available weather evidence. Joyce E. Chaplin is studying historical almanacs for her research on early America and climate change. She reports that of the almanacs she has examined, just over 8% have weather notes, and less than 1% use instrumental data in thermometer readings. About 16% of the almanacs are pocket almanacs. These are personal documents used daily by those interested in agriculture and perhaps other weather-related concerns such as shipping, travel, or ice harvesting. Few if any of the almanacs carry names, as they would be kept on the person as would a modern wallet or cell phone, easy to access and well-used. They also have room for notes in the margins to record the weather and related events. As one owner noted, an ice-out in Boston Harbor happened in March that year. With sufficient reports over a longer, denser time series, the almanacs could potentially document a relative baseline for ice-out in Boston (Chaplin 2021). These almanac notes are not likely to provide uniform and reliable information, and the location might be untraceable unless the owner wrote in an address, but depending upon the collection, major events such as storms, and pivotal ones such as a free and clear harbor (in a named harbor) could be used for reference. It can be quite an asset to have a historian help establish the research samples.

Historical Context

The historian will look out for broader social influences on the data alongside biases. When researchers studied human-caused fire events in the USA's Midwestern Tallgrass Prairie between 1673 and 1905, they examined the frequency of fires. They wanted to document their historical occurrence for informing "legislation aimed at reducing their occurrence, and to inform ecological managers of the historical fire regimes" (McClain et al. 2021, 284). The researchers recognized that the dramatic decline of documented fires started by Indigenous peoples despite the increasing number of European travelers, explorers, and settlers present to report on such fires was *not* due to government restrictions on fire, but to the absence of the Indigenous residents. Their deaths from murder, battles, and sickness; their absence due to removal from the land; and the lack of burning due to forced changes in hunting patterns and practices, had significantly influenced fire frequency started by Native Americans. It was not due to changes in governmental regulation of their fire practices (McClain et al. 2021).

This is different from the western region of the USA where a common refrain in wildfire media coverage is that traditional practices by Indigenous peoples reduced the available ground fuel for fires which limited the number of sweeping and uncontrolled fires; that, with the advent of US governmental management, the elimination of this native forest and land management approach has contributed to the current experience of more frequent and more damaging fires in places where potential fuel has been allowed to accumulate. The answer is more nuanced. Yes, when Indigenous people are not allowed to pursue cultural burn practices, there will be a build-up of materials in the places where they practice burning. That can mean the fires would be more likely to burn more widely and longer and hotter if they do occur. The 20th-century regulations of quick knockdowns to put out naturally occurring forest fires within 24 hours may have limited immediate fire damage but it, too, allowed a build-up of naturally occurring fuel which is readily burnt by fire exacerbated by climate change-driven drought, heat, and winds.

The comparison of data between Midwestern Tallgrass Prairie and Pacific Northwest forests is certainly not one-to-one, and the mix of fire data with differing social contexts illustrates that fire frequency alone is not an indicator of climate change.

Interpreting Environmental versus Climate Context

In earlier chapters, we saw how the study of historic eggshells in museum collections helped make the case that DDT harms wildlife. It is an iconic example of how museum collections can demonstrate environmental degradation. What we are looking for in documentary collections is evidence of human-driven climate change. It can be easy to confuse environmental changes with climate changes if the researcher, collector, or observer is less knowledgeable about climate change, or if there are influences that are unseen or hard to detect.

When studying these systems and asking questions about what is happening and how the environment and climate interact, the two most common explanations are "it's complicated," and "it depends." Sometimes both are involved, sometimes only one aspect. This makes careful sorting of environmental versus climate change data and influences so important and challenging. A researcher's incomplete understanding of the environment and climate creates a risk of misattribution of data.

The environment is what is around you, what you are experiencing. The climate is what is around the world, and its conditions over decades and centuries. Both are a mix of systems that go beyond your current location and that connect to other systems. The dynamics of climate systems affect environmental systems. When the climate is stable, the influences and impacts are rather stable; but when it's changing, the environment will reflect those changes. However, not every change in an environment is caused by climate, and not every change in the climate creates related or equal changes in environmental changes across the globe. Impacts result often only in some places, or much more in some places than in others.

As museum collections managers, curators, exhibit designers, and educators come to understand more about how to study and recognize climate change, we are learning to see distinctions among events and information within data sources. As museum workers begin to work more with climate-related research questions, they are also likely to start seeing climate influences and indicators where they had overlooked them before. They may also "see" them even when they are *not* there: a climate-change bias can sneak in. This is where the multiproxy approach has its value: it uses corroborative data, making it more detailed and yet less easy to subvert. Remember, climate change cannot be measured directly, but the changes it forces and the impacts it leaves can be measured through proxy data. Researchers can increase their confidence in documentary climate signals by using expanded proxy datasets and multiproxy approaches (Luterbacher et al. 2004, 1499), and the use of methodologies such as indexing and calibrating (Luterbacher et al. 2004; Nash 2018; Gil-Guirado et al. 2019). But the researcher must have a solid understanding of the environment and climate.

Shoreline erosion is a tempting arena for climate assumptions. Shoreline erosion and cultural heritage losses are often correctly attributed to wave action driven by sea level rise and storm events resulting from climate change. However, coastal erosion can also be a result of the harvest of sand, gravel, shale, etc., by individuals and organizations. This extraction exposes the shoreline to this wave action where it would not have been before. In a study of coastal erosion, visual documentary data demonstrated how artistic evidence can record a change in a way that embodies the human and natural impacts. Instruments alone could not illustrate this. The comparative series of an English seaside begins with an 1869 painting and progresses through an 1885 photograph of the village's main street, a late 19th-century image of the beachfront, and a 2016 photograph showing no beach and only some homes remaining. In this case, the loss was accelerated significantly by the harvesting of shoreline shale for building construction, leaving the sand and soil cliffs exposed to waves that climate change has now made stronger and that reach farther inland due

to sea level rise (Momber et al. 2017, 35). In another example, the beach erosion on a Fijian island, which might be assumed as caused by wave action driven by sea-level rise and storm events, was discovered instead to be due to locals' sand mining rather than climate change. There were similar findings in Vanuatu and Samoa during related climate change adaptation research with island communities (Nalau et al. 2018, 859). In these latter two cases, speaking with the community was a part of the study to understand ongoing very recent changes.

Researchers must be prepared for evidence of change attributable to humans affecting not just the land but also site features. The size or height of a structure or marker, as measured in an image or in the field, may have been changed. This would influence related measurements. Perhaps rather than loss due to erosion or submersion, marker stones may have been moved or removed for other uses. These changes could be in response to sea level rise and resulting migration, or a choice to reuse materials elsewhere. This is where establishing both the social and ecological contexts of the record is critical to good research and science.

Identifying Human Environmental Interference versus Human-driven Climate Change

First, remember that while climate change is a global event, it is experienced locally, which influences the data. The Pacific Northwest is not the Midwestern Tallgrass Prairie. The peoples of one place are not those of another. And regulations and environmental conditions everywhere are a product of the people and practices of that place. And since climate change is not uniform, its impacts are not evenly distributed. This means that when we look at global *average* temperatures, we overlook extreme heat experienced by a region (Luterbacher et al. 2004). Similarly, when we take the data of a region and identify an extreme heat event, we must consider if it was a regional event due to local conditions, or a regional or wider event that was part of a climate trend. This is why historians need climate scientists.

Second, environment and climate, like communities, are systems made of systems. They have different components and varying scales, but they are dynamic systems. Inside them are parts and processes, and mechanisms and relationships that interact, whether or not we see these interactions or know they are there. Single acts may trigger a change within those systems, but the connections within the systems and the opportunities for corroborating acts or events will all contribute to the reactions following that trigger. As illustrated later by Primack and Miller-Rushing, when examining these systems to draw conclusions, researchers must be sure to attribute changes to the correct series of influences.

Misattribution of climate change or environmental data, and human and environmental influences is a real danger. Environment and climate are closely connected, frequently overlapping. In the example of the reduced cultural burns and the 24-hour fire "limit" contributing to fuel in the forest, whether or not those fires were caused by climate-related triggers, they are certainly made bigger and hotter by the heat, drought, and windstorms that come with climate change.

Threats to species and species loss are common themes in climate work, but not all species loss is due to climate change, and not all species suffer in a changed climate. Fish population is a tempting area for this misattribution. As measured in their presence on historical menus and in fishing records, their fluctuations reflect numerous influences of its availability: abundance, accessibility, available fishing technology, limits and benefits of regulation, taste, culture, etc. To attribute their presence or absence simply because of climate would be to overlook many other potential influences in the system. Studies have highlighted changes over time as reflected in historical restaurant menus by the presence of fish species on offer and their pricing. The researchers might have considered fish availability to have potential connections to climate change, but in practice found a science-buttressed story of environmental damage and of demand due to "status, ethnicity, and evolving perceptions of food ..." (Braje and Bentz 2021, 4). This research highlights the importance of museum collection documents and specimens for creating historical, social, and environmental context for improved results (Pauly 1995; Collins et al. 2005; Braje and Bentz 2021; Schijns et al. 2021).

Noise in the Data

Environmental data do not always indicate climate change and may act as noise in the climate data. William Lloyd Sutton, M.D., (1926–2014) was a toxicologist working for Eastman Kodak Company in Rochester, NY, when he began his amateur fly-fishing career in earnest (1963). His journals record his experiences as he learned to fish, to read the water, and to understand the habitat. The family collection covers about 60 years, with 30 of them spent regularly fishing at the Philip Garbutt Rod & Gun Club on Oatka Creek (Sutton Family Collection). It is tempting to take his long time series of data as a potential resource for climate change study. Dr. Sutton very consistently noted the date, air temperature, and current and recent weather events; he measured the water temperature and depth; noted the insects hatching, swarming, and being eaten by the fish; and noted his catches by species, size, and condition. This information could help him understand what flies to tie (and how to do it) to improve his catch. Understanding the conditions helped him determine when the fishing would be productive or not. To a researcher years later, his notes could help interpret hatch dates for mayflies, and shifts in air and water temperature, due to climate change. Though the hatching record and the temperature data may be useful, the water flow data was human interference.

Sutton's streamflow notes are an example of noise in the data. As internet resources and services expanded, a fisherperson or researcher would eventually have access to streamflow data online for New York State through the United States Geological Survey website (USGS, n.d.) using data provided by the New York Water Science Center. There was peak streamflow data collected for Oatka Creek since 1946, and water quality sampling since 1954, but Sutton would not have had access to it, so he recorded it himself. There was also surface water discharge data for

Oatka Creek at the Garbutt Club on a monthly and annual basis from 1946 through 2020. Again, it was not available in real-time to the fisherman when Sutton was active. A researcher using only Sutton's documentary data would not have recognized this streamflow interference. The discharges and reduced flows were a "result of regulation" and not a result of climate influence (Arthur Lilienthal, email with the author, January 12, 2022). So, where the instrument data tells us much about the activity of the river, the documentary evidence tells more about the life in the river. Sutton's diary data includes water temperature records that the state does not have. It only collected this information for 18 months between 1959 and 1961. His sampling skills were later put to use for the New York State Department of Environmental Conservation (NYSDEC) collecting macroinvertebrates in samples from four creeks as the department examined water quality. There were statewide concerns about human health impacts for swimming and the consumption of fish. His years of noting and documenting the insects those brown trout preferred were put to good environmental use but not on climate change (NYSDEC 2002, rev. 2015).

Since humans cannot see and understand all that is around us or is impacting the social, planetary, or ecosystems as we examine historical data or collect new data, they must research context and seek corroboration to eliminate or manage the non-climate parts of the story, the "noise" in the climate data. Sometimes the noise is due to an error; sometimes it is due to non-climate issues. Noise is interference or influence of some form that must be understood and isolated, or at least recognized, when interpreting the information. Noise happens physically in machines and radio signals, but it also appears figuratively in statistics, and physically in phenomena. Curt Stager and colleagues, who study weather in the Adirondacks, describe how the noise can be an important issue for the researcher to investigate. Local discrepancies in a 2001 agency report were discovered to be due to "gaps and errors in the raw instrumental records" (Stager et al. 2009, 14) and a reexamination eliminated the noise in the data. Full context is critical for good research.

Environmental disturbances or shifts often influence climate data. In Primack and Miller-Rushing's study of bloom times in Concord, historically and present day, with temperature readings, they knew enough about climate science to recognize that increasing urbanization in Boston and suburbanization in Concord have increased the amount of heat-absorbing surfaces such as buildings, roads, and parking lots, and has decreased the availability of buffering cooling mechanisms, for example, trees, meadows, and agricultural fields (Primack and Miller-Rushing 2012, 176). The presence of these warming surfaces creates an urban heat island effect, and it "accounts for about two-thirds of the increase in Concord's and Boston's temperature since the 1850s" (Primack 2014, 50). The other third they attribute to general global warming (50–51). Because the research purpose was to identify any or a degree of impacts due to climate change, the human interference of built structures created temperature changes that were not attributed solely to climate change. Those temperatures were noise in the climate temperature data. When studying migratory bird arrival dates in spring, Primack and Miller-Rushing

found that field sparrows documented during Thoreau's time could not be relied upon to provide comparative results: today they overwinter in Concord (Primack and Miller-Rushing 2012, 176). This means the behavior being studied changed because people provide food and shelter that allows them to overwinter. This interference contributes noise to the study. A researcher must understand or come to understand the subject thoroughly to guard against such noise in the study from changes in data over time. Broader research teams and partnerships limit these oversights, developing a more accurate examination of change over time.

Local Disparities—Noise or Better Data?

The way humans have built communities influences the environment and can contribute to climate change while making climate change impacts worse. Climate researchers know that the choices we humans make to adapt to climate change (changes to building and land use and policies) and to develop resilience mechanisms (cultural shifts, stories, events, and social structures) could be distorting and noisy in the data. The coastal erosion on the English seaside and the urban heat island effect in the Concord research are examples. It is important to understand how environmental and climate change intersect, and working with climate scientists and others can help. As another example, just as flooding experiences can be worse closer to a water source than a mile or more away or uphill, they can be worse in urban areas with impervious surfaces (pavement and roofs that water does not penetrate) where water runoff builds up. This is in contrast with rural areas with more undisturbed land that allows the water to percolate into the soil and be absorbed rather than becoming a torrent on the surface. And it can be worse where there are other disturbances such as mining and the removal of forests that degrade the land and can increase water runoff leading to flooding. Researchers must recognize this land-use influence on the flood data. Humans changed the environment so that when climate change-driven storms occur the impacts are worse.

This is also where scale matters. Research in Indonesia, comparing national reports with local news and interviews, shows that a focus on national numbers and disaster-level scales can obscure subtler and broader impacts most important to those experiencing them. Researchers conducted interviews with those who experienced the flooding and could comment on the frequency and extent. The researchers coded the language of their responses in much the way researchers coded written language describing flood events in documents using indexing methods. They found that national data reporting in this case of Indonesian events did not reveal the actual extent and impacts of flood events (Wells et al. 2016, 5). The researchers make a case for combining all three sources of data, national reports, local news, and local interviews, to create a fuller picture of climate change. This approach of local interviews collected in an ethnographic manner is part of cultural consensus reporting, an increasingly important method of obtaining local information rooted in the current experience of place and people (Carothers et al. 2014).

Humanists' Role in Recognizing Environment versus Climate

This can be illustrated with a return to the examination of wildfire. Wildfire is an event that occurs in a specific environment and can be worsened by climate change. Wildfires have a trigger, but the scale and impact of the fire are not a result of the trigger but of the mechanisms it connects to. There must be fuel and conditions that encourage the fuel to burn. A fire that starts in a place where it is managed, and the risk of exposure to species and materials is limited, is very different from a fire that starts near homes and communities, or in sensitive habitats, and burns without control. The urban–wildlands interface is that edge where physical property meets wild spaces, where fire can reach into spaces where lives, livelihoods, and assets are damaged. People and their assets have moved right to the edges of wildfire zones just at a time when the climate is making these conditions more hazardous. The climate drives the chance of fire, but the population expansion and location drive the exposure to the climate risk of fire.

As mentioned earlier, if we compare the incidence of wildfire over time, frequency is not sufficient evidence of a changing climate. Should the post-contact fire rate be attributed to the suppression of cultural burns, to the severe population loss for Native peoples who would have practiced cultural burning, or to the exclusion zones for burning such as on lands deemed public by the US government (McClain et al. 2021, 283)? In the Pacific Northwest of the USA, Native peoples were more likely to be constrained on reservation and trust lands within the region of their homelands, while those in the Midwest were more likely to have been removed from homelands and pushed west (Long and Lake 2018, 1–2). In both cases, removal, restrictions, and death led to reduced burn activities. When documenting wildfire frequency over time, the research question is not only were there more or fewer fires over more or less land, but what kinds of fires were there, who conducted them, and how their frequency relate to populations and policy? Historic understanding helps understand the environmental and climate stories by isolating and responding to the social, cultural, and historic noise in the data *and* the influences on the experiences documented. This is why scientists and historians, respectively, make such great co-researchers. And nowhere else is the value better demonstrated than with knowledge integration of western science and ITK and TEK.

Accuracy, Trust, and Completeness in the Data

How do researchers build trust in these data if there are concerns about noise and interference; bias in the observers, collectors, and researchers; and many are only just learning to appreciate other approaches such as the blending of western science with ITK and TEK? How can there be complete data if observers and participants are so often left out (Belfer et al., 2017, 66-68)? Accuracy is a challenge in any research, and is continuously addressed through transparent methods, tested methodology, and comparative approaches. The cultural heritage sector and the

researchers using cultural heritage in climate change research are building these skills as they accumulate data. Where science lacks a measured base for agricultural productivity, the community may have shared knowledge of fish abundance, agriculture changes, and shifting sources of foods. In addition to the indexing and calibrating for documentary evidence described previously, and blending ITK and TEK with western science, researchers have been developing best practices for determining the reliability of using maps, images, and depictions of landscapes for climate change research. Let's examine maps and images that can help round out these stories.

Accuracy in Maps

Surveyors' journals and maps from 19th-century Australia are an example of how maps contain data that may be useful for comparison today (Kenyon 2015; Mercer 2019). In addition to map-making, these surveyors were tasked with describing the climate of the regions they explored. With the help of Aboriginal Australians, some reported learning to recognize landscape features that were clues to climate. That record may help us compare today's evidence to these early 19th-century observations and understand change over time. One surveyor's Wiradjuri guide taught him that goborro trees were an indicator of transient or intermittent water, and river red gum trees indicated permanent water in lakes or rivers. They taught him to recognize flooding marks on yarra trees indicating the range of flooding that took place at a time different from his visit in 1825. Since these trees are known to require flooding every seven years for continued survival, it provides a comparative timescale for events. In sparsely populated areas, especially those where no one was using rain gauges for measurement, this documentary data can provide information to compensate for the lack of instrumental data. Precipitation information appears far less frequently in historical climatology records than do temperature measurements, but both indicators can reflect the behavior of atmospheric systems—a significant component of climate—and, together, provide more regionally specific illustrations of climate (Mercer 2019). Though these maps alone do not demonstrate climate change, they provide information about a region that can be used to compare to current experiences of flood events. For example, if current rainfall records reflect no such flooding events or much-reduced events, and vegetation records indicate that the trees no longer thrive in this location, this can illustrate changes in the climate significant enough to affect tree growth.

Here again, the researcher must consider if subsequent or current conditions reflect human construction rather than climate activity. The Australian maps were part of exploratory trips, either the first or subsequent ones, in the early decades of the 19th century, reflecting what surveyors and explorers saw at the time and marked to the best of their ability on the maps. These maps were prepared describing the location and extent of rivers, marshes, vegetation, and other markers on the landscape. The vegetation mapped is considered to be the "vegetation

communities managed by the Aboriginal people prior to European arrival" (Kenyon 2015, 8). So they are not naturally occurring but can be assumed to be cultivated in harmony with the environment using indigenous knowledge systems and world views. The subsequent changes in the vegetation might not only be attributed to climate change, but may be affected by a shift from Aboriginal management to the impacts of settlement, just as with the fires in the American West. In the early 19th century, Australian maps and reports name a type of Eucalyptus that was infrequent along the natural river, were common along much of its length by the late 19th century. Settlers had built levees for managing water, keeping floodwaters from spreading, uncontrolled, and out across the land. During high precipitation times, the levees would be opened, creating areas that were flooded more substantially than when the river ran naturally, and now hosted Eucalyptus (9). The environmental conditions of flooded plains that led to an increase in vegetation were at least partially influenced by human-made changes in the landscape, not solely climate changes.

Maps can also simplify assessments at coastal boundaries and edges where critical details can be more precisely confirmed than on land alone (Momber et al. 2017, 37–38; Brooks et al. 2011, 573). This does not mean that land maps are unreliable, but that there will be very clear reference points for comparison when studying an edge rather than an expanse. The Maritime Archaeology Trust (UK) examined and tested the use of historic maps along with photographs, charts, and archaeological and paleo-environmental data to consider their value in studying long-term coastal change. In determining the reliability of maps for this work, researchers assessed three aspects: the topographic value by looking for the presence of distinctive features described in sufficient detail; geometric accuracy for distances, using comparisons with modern software; and time aspects for date of completion and whether the resource was a copy (prone to compounding errors) or the original (Momber et al. 2017, 38–39).

On a European coastline, over the ages, there would be fishing sites, villages, ports, fortresses, fortifications, barriers, homes, roads, and ceremonial sites. If they were captured in maps, photographs, and charts, they can be a reference for that point in time. When combined, these records can illustrate a site's "relative position to the sea," and then can support measurement for changes in that position. The challenge is to attribute changes appropriately. Did the land sink or get lifted up? Was there erosion or accumulation? Was a reference point or a building moved at any time? Since historians study changes over time, these questions are not new, but the paths to the answers may require knowledge common to climate researchers. Depending upon the location and study period, the change could be attributed to subsidence when glaciers melted, groundwater was removed, or a mine or other subterranean chamber opened or collapsed. Climate-driven sea level rise could mean the site became submerged or the water's edge has crept closer, and that waves reach farther inland. Coastal erosion could be climate-driven through increased intensity and reach of waves during storm events, or global warming that reduces or eliminates shoreline sea ice that previously protected the coast from winter storms.

Accuracy in Art and Images

The Maritime Archaeology Trust tested the reliability of artworks and depictions as part of the documentary research mix in assessing sea-level rise, again establishing criteria likely replicable in many other research opportunities. Of course, they took into consideration the view and its inclusion of shoreline, cliffs, vegetation and structures, and the date, as with the maps, but for photographs, the view also matters for the clarity and substantial presence of the research subject (the coast) in the image; the heritage features included in the image; the photographic quality; and the purpose of the photograph as a potential reflection of intentional or unintentional bias. An image for reporting purposes, for example, does not have the same purpose as a family photograph. When they examined artworks, they found that breaking them into distinct categories of style and medium helped establish criteria. The style categories were "caricaturist and genre works, picturesque landscapes, marine and shipping subjects, topographical artworks including beach and coastal scenery, and, finally, topographical artworks including beach and coast scenery with a Pre-Raphaelite influence" (Momber et al. 2017, 38–39) The medium (type) categories were copperplate engravings, oil paintings by Norwich School and Pre-Raphaelite artists, steel plate engravings and aquatints, lithographs or fine pencil drawings and watercolor drawings, "and watercolour drawings by Pre-Raphaelite artists and their followers." They found the accuracy of Pre-Raphaelite materials to be the greatest and copperplate engravings the weakest (38–39). This meant that for further research, copperplate engravings would be a source of last resort.

This is important research: visual depictions of places people care about are valuable for engaging their thinking on the physical impacts of climate change. In the research described above, four images illustrate change over time as the shore erodes and a village is almost entirely lost to the sea since the shingle harvested for other buildings left the cliffs exposed to wave action. Whether or not you live in England, the village and the people who live there are clearly very real. Viewers can feel the losses of their village life, and the risk for those who remain. Visual art and images are valuable for documenting climate change in a way that engages the viewers. Their effective use is an emerging area of research museums can recognize and encourage.

Emerging Approach to This Work

In examining all these types of data, resources, and approaches to using them, some aspects emerge as important for the cultural heritage professional examining a museum collection for climate data:

- Establish the context of the collection—the collector's biases; the environmental, geographical, and climate contexts; and the potential type of climate change information.
- Identify researcher biases.

- Develop a familiarity with the material's source, language, format, references, location, and conditions.
- Identify research partners with access to complementary or additive datasets.
- Establish a shared understanding of the differences among data formats and their values.
- Normalize or at least record the protocols and methodologies being used in the historical and modern research.
- Continuously differentiate environmental impacts and changes, and climate-change-driven impacts and changes.
- Identify any baselines that have shifted that influence your comparative data.
- Confirm your understanding of the systems' interactions through general knowledge-building and through observation of the system and available data.
- Confirm the climate change drivers and their impacts.
- Describe the changes over time and the comparative references for your hypothesis.
- Test your evaluation.

Primack and Miller-Rushing were very clear about the value of museum collections and access to their data for such ground-breaking work as theirs:

> We were fortunate … to be able to locate many unique, unanalyzed, and underappreciated data sets that could be analyzed in light of climate change. The importance of libraries, research institutions, and museums in maintaining such valuable historical records cannot be overestimated. Without such records, this work could not be done.
>
> *(2012, 179)*

The challenge now is how to bring this information off the page and into the mind and experiences of our visitors.

References

Belfer, Ella, James D. Ford, and Michelle Maillet. 2017. "Representation of Indigenous Peoples in Climate Change Reporting." *Climatic Change* 145, no. 1–2 (November): 57–70. https://doi.org/10.1007/s10584-017-2076-z

Braje, Todd J., and Linda Marlene Bentz. 2021. "Bills of Fare, Consumer Demand, Social Status, Ethnicity, and the Collapse of California Abalone." *Journal of Ethnobiology* 41, no. 2 (July 5): 277–291. https://doi.org/10.2993/0278-0771-41.2.277

Brönnimann, Stefan, Rob Allan, Linden Ashcroft, Saba Baer, Mariano Barriendos, Rudolf Brázdil, Yuri Brugnara, et al. 2019. "Unlocking Pre-1850 Instrumental Meteorological Records: A Global Inventory." *Bulletin of the American Meteorological Society* 100, no. 12 (December 1): ES389–ES413. https://doi.org/10.1175/BAMS-D-19-0040.1

Brooks, Anthony J., Sarah L. Bradley, Robin J. Edwards, and Nicola Goodwyn. 2011. "The Palaeogeography of Northwest Europe during the Last 20,000 Years." *Journal of Maps* 7, no. 1 (November): 573–587. https://doi.org/10.4113/jom.2011.1160

Businger, Steven, M. Puakea Nogelmeier, Pauline W. U. Chinn, and Thomas Schroeder. 2018. "Hurricane with a History: Hawaiian Newspapers Illuminate an 1871 Storm." *Bulletin of the American Meteorological Society* 99, no. 1 (January 1): 137–147. https://doi. org/10.1175/BAMS-D-16-0333.1

Carothers, Courtney, Caroline Brown, Katie J. Moerlein, J. Andrés López, David B. Andersen, and Brittany Retherford. 2014. "Measuring Perceptions of Climate Change in Northern Alaska: Pairing Ethnography with Cultural Consensus Analysis." *Ecology and Society* 19, no. 4 (December): 27. http://dx.doi.org/10.5751/ES-06913-190427

Chaplin, Joyce E. 2021. "Climate in Words and Numbers: How Early Americans Recorded Weather in Almanacs." Lecture, Massachusetts Historical Society, virtual event, March 9, 2021.

Collins, Terry, Anne Marboe, Darlene Trew Crist, and Sara Hickox. 2005. "Restaurant Seafood Prices Since 1850s Help Plot Marine Harvests through History." News release, Census of Marine Life, October 23, 2005. http://www.coml.org/comlfiles/press/ HMAP_news_10-24-05.pdf

Gil-Guirado, Salvador, Juan José Gómez-Navarro, and Juan Pedro Montávez. 2019. "The Weather behind Words – New Methodologies for Integrated Hydrometeorological Reconstruction through Documentary Sources." *Climate of the Past* 15, no. 4 (July 10): 1303–1325. https://doi.org/10.5194/cp-15-1303-2019

Hughes, J. D. 2014. *Environmental Problems of the Greens and Romans: Ecology in the Ancient Mediterranean*, 2nd edition, 1–7. Baltimore: Johns Hopkins Press.

Huhtamaa, Heli. 2020. "The Good, Bad, Undefined Little Ice Age." *Historical Climatology*, June 3, 2020. https://www.historicalclimatology.com/features/ the-good-bad-undefined-little-ice-age

Kenyon, Christine. 2015. "An 1830s Map: Whose Map of the Mid-Murray River Is It?" *The Globe* 76 (January): 1–12. https://search.informit.org/doi/10.3316/ informit.991172089248895

Kharouba, Heather M., Jayme M. M. Lewthwaite, Rob Guralnick, Jeremy T. Kerr, and Mark Vellend. 2018. "Using Insect Natural History Collections to Study Global Change Impacts: Challenges and Opportunities." *Philosophical Transactions of the Royal Society B* 374, no. 1763 (November 19): 1–10. https://doi.org/10.1098/rstb.2017.0405

Long, Jonathan W., and Frank K. Lake. 2018. "Escaping Social-Ecological Traps through Tribal Stewardship on National Forest Lands in the Pacific Northwest, United State of America." *Ecology and Society* 23, no. 2 (June): 1–14. https://doi.org/10.5751/ ES-10041-230210

Luterbacher, Jürg, Daniel Dietrich, Elena Xoplaki, Martin Grosjean, and Heinz Wanner. 2004. "European Seasonal and Annual Temperature Variability, Trends, and Extremes Since 1500." *Science* 303, no. 5663 (March 5): 1499–1503. https://doi.org/10.1126/ science.1093877

McClain, William E., Charles M. Ruffner, John E. Ebinger, and Greg Spyreas. 2021. "Patterns of Anthropogenic Fire within the Midwestern Tallgrass Prairie 1673–1905: Evidence from Written Accounts." *Natural Areas Journal* 41, no. 4 (October 18): 283–300. https://doi.org/10.3375/20-5

Mercer, Harriet. 2019. "Are Surveyors' Maps and Journals an Untapped Source for Climate Scientists?" *Historical Climatology*, December 3, 2019. http://www.historicalclimatology. com/features/are-surveyors-maps-and-journals-an-untapped-source-for-climate-scientists.

Meineke, Emily K., and T. Jonathan Davies. 2018. "Museum Specimens Provide Novel Insights into Changing Plant–Herbivore Interactions." *Philosophical Transactions of the Royal Society B* 374, no. 1763 (November 19): 1–14. https://doi.org/10.1098/rstb.2017.0393

Momber, Garry, Laruen Tidbury, Julie Satchell, and Brandon Mason. 2017. "Improving Management Responses to Coastal Change: Utilising Sources from Archaeology, Maps, Charts, Photographs and Art." In *Public Archaeology and Climate Change*, edited by Tom Dawson, Courtney Nimura, Elías López-Romero, and Marie-Yvane Daire, 1st ed., 34–43. Philadelphia: Oxbow Books.

Nalau, Johanna, Susanne Becken, Johanna Schliephack, Meg Parsons, Cilla Brown, and Brendan Mackey. 2018. "The Role of Indigenous and Traditional Knowledge in Ecosystem-Based Adaptation: A Review of the Literature and Case Studies from the Pacific Islands." *Weather, Climate, and Society* 10, no. 4 (October 1). 851–865. https://doi.org/10.1175/WCAS-D-18-0032.1

Nash, David J. 2018. "Reconstructing Africa's Climate: Solving the Riddle of Rainfall." *Historical Climatology*, November 12, 2018. http://www.historicalclimatology.com/features/reconstructing-africas-climate-solving-the-riddle-of-rainfall

New York State Department of Environmental Conservation. 2002. *WI/PWL Fact Sheets - Lake Ontario/Irondequoit Creek Watershed*. 0414010107. Revised 7/30/2015. https://www.dec.ny.gov/docs/water_pdf/wilkontcirondequoit.pdf

Pauly, Daniel. 1995. "Anecdotes and the Shifting Baseline Syndrome of Fisheries." *Trends in Ecology & Evolution* 10, no. 10 (October): 430. https://doi.org/10.1016/S0169-5347(00)89171-5

Pfister, Christian, Jürg Luterbacher, Heinz Wanner, Dennis Wheeler, Rudolf Brázdil, Quansheng Ge, Zhixin Hao, Anders Moberg, Stefan Grab, and Maria Rosario del Prieto. 2008. *Documentary evidence as climate proxies*. White paper written for the Proxy Uncertainty Workshop in Trieste, June 9–11, 2008 (updated December 2008). https://www.ncei.noaa.gov/pub/data/paleo/reports/trieste2008/documentary.pdf

Primack, Richard B. 2014. *Walden Warming: Climate Change Comes to Thoreau's Woods*. Chicago: The University of Chicago Press.

Primack, Richard B., and Abraham J. Miller-Rushing. 2012. "Uncovering, Collecting, and Analyzing Records to Investigate the Ecological Impacts of Climate Change: A Template from Thoreau's Concord." *BioScience* 62, no. 2 (February): 170–181. https://doi.org/10.1525/bio.2012.62.2.10

Schijns, Rebecca, Rainer Froese, Jeffrey A. Hutchings, and Daniel Pauly. 2021. "Five Centuries of Cod Catches in Eastern Canada." *ICES Journal of Marine Science* 78, no. 8 (November): 2675–2683. https://doi.org/10.1093/icesjms/fsab153

Stager, J. Curt, Stacy McNulty, Colin Beier, and Jeff Chiarenzelli. 2009. "Historical Patterns and Effects of Changes in Adirondack Climates since the Early 20th Century." *Adirondack Journal of Environmental Studies* 15, no. 2 (January): 14–24. https://digitalworks.union.edu/ajes/vol15/iss2/5/

Sutton, William L. 1963. *Journal 1962-1966*. Collection of the author's family.

United State Geological Survey. n.d. "USGS Water Data for the Nation." Accessed February 28, 2021. https://waterdata.usgs.gov/nwis

Veale, Lucy, Georgina Endfield, Sarah Davies, Neil Macdonald, Simon Naylor, Marie-Jeanne Royer, James Bowen, Richard Tyler-Jones, and Cerys Jones. 2017. "Dealing with the Deluge of Historical Weather Data: The Example of the TEMPEST Database." *GEO: Geography and Environment* 2, no. 2 (August 17): 1–16. https://doi.org/10.1002/geo2.39

Wells, Jessi A., Kerrie A. Wilson, Nicola K. Abram, Malcolm Nunn, David L. A. Gaveau, Rebecca K. Runting, Nina Tarniati, Kerrie L. Mengersen, and Erick Meijaard. 2016. "Rising Floodwaters: Mapping Impacts and Perceptions of Flooding in Indonesian Borneo." *Environmental Research Letters* 11, no. 6 (June 20): 1–15. http://dx.doi.org/10.1088/1748-9326/11/6/064016

4

UNTAPPED POTENTIAL FOR PUBLIC ENGAGEMENT

The world has got itself into a climate mess, and into a near-impasse socially, arguing about the science of climate change and the economic impacts of redesigning how the world functions. The museum sector perpetuates the scientific emphasis as the front door to climate understanding. However, the forces of change are far greater than can be interpreted by science alone. Rob Nixon, in his essay "The Anthropocene and Environmental Justice," writes "Giving the Anthropocene a public resonance involves choosing objects, images, and stories that make visceral those tumultuous geologic processes that now happen on human time scales. How can we most effectively curate and narrate the Anthropocene…? What objects, images and stories can best express" the global experience in ways that illustrate scale and variety of change? (Nixon 2017, 23). To inform a broader audience and to provide more paths for raising awareness and creating opportunities for engagement and action, there must be an expansion of the resources for and formats of climate change research, documentation, and action.

In 2021, wave action in Sydney, Australia, revealed stone outcroppings usually hidden beneath the sands of a well-visited beach. In the decades previous, after similar but unusual and dramatic scourings, people had carved names and dates into the stone uncovered when the sand was washed away: "W. Tunks 1974" and "Stoneman 4-6-78" for example (Hartley 2021). Those dates aligned with wave action modeling estimates indicating those storm events as published in 2009. Of course, there would have been a written record of the events, but the subsequent regression modeling research provided the explanation to go with the human experience. Mitchell D. Hartley, lead author of the 2009 "multi-decadal beach survey dataset" linking "erosion/accretion cycles coinciding with phase shifts in the El Niño/Southern Oscillation (ENSO)" posted the Tweets showing images of those decades-old carvings. The study concluded that La Niña wave events have a greater impact than El Niño wave events (Hartley et al. 2009). To many, the images

DOI: 10.4324/9781003044765-5

communicated more than they would glean from the academic paper if they ever had the chance or reasons to read it. The before and after images of the beach posted on Twitter illustrated the degree of change. The additional close-ups of the carvings connected people across the decades sharing that experience. Though not driven by climate change, the example illustrates the power of experience, place, and imagery to communicate abstract global forces in a more personal way.

Approaches based on humanities sources can contribute to information-sharing on environment and climate in ways that complement scientific approaches and are accessible and attractive to members of the public (and the museum profession) who are less interested in a science-based approach. This chapter focuses on encouraging the use of humanities data in public engagement through museums. Though there are very few implementation examples to share, there is the expectation that by using common exhibition and program practices, combined with crowdsourcing and digitization efforts to uncover more data, the museum field will see a significant increase in practical applications in the next decade.

Ours, Theirs, or Both

The museum profession can participate in the multi-domain climate change discussion through its own curatorial practice and public engagement, or through others' research for academic papers. Both are valid. The latter is by far the most common. This is a call for the sector to accelerate climate interpretation and engagement through intentional climate curatorial practice, and to partner with the researchers to do it well. Bonnie Styles, an experienced researcher and administrator in the science museum profession, points out that unfortunately staff in "museums tend to not talk about their research" despite the "public [being] so excited to hear about who does the research" (conversation with the author, summer 2021). This must change if the practice of unlocking collections for climate change research can expand sufficiently to help address the global challenge.

Frequently during research interviews for this book, museum professionals distanced themselves from the few documentary-based climate research projects that had museum-based sources. The staff responded that they do not influence research outcomes, and that they create their own exhibits rather than exhibits for other researchers. Similarly, some research and monitoring agencies using digitized and digitally born data did not know where the original, pre-digital records in their time-series had been created or were currently kept, and showed no interest in exploring the discussion further. Many of the articles identified during the research for this book were written by academic researchers only, with few museum staff included in the credits, and collection locations only occasionally cited. Whatever the reason for the approach, when museums do not share their collections or actively engage with and benefit from the resulting discoveries, too much scientific and humanistic discovery is lost or overlooked. The importance of the opportunity is clear to the published researchers who had used documentary data. They were enthusiastic and made calls for expanded access to and use of documentary records (Primack and Miller-Rushing 2012; Diemberger et al. 2012; Pfister et al. 2008).

Similarly, Charles F. Kemmel wrote in a prelude to a report on a 2011 meeting in Cambridge, UK, on climate histories, that

> Historians, resource economists, geographers, anthropologists, and many others have roles to play in assessing the human impacts of climate change. In the end, it will all come down to public communication. Decisions will be neither made nor implemented without public understanding. And the most important question for each and every individual in the public is, What will climate change mean for the people and things I care about? Here is where the human disciplines should shine.
>
> *(Diemberger et al. 2012, 226)*

In the meeting report, the two main essayists and their respondents wrote that the agency for addressing climate change, and the proxies for demonstrating it, were elusive but not imaginary. A decade later this remains true. There is slow progress; expanding this work is critical for meaningful change. Respondent Mike Hulme comments that

> it is harder than one might think to discover where climate change is happening. If it is 'out there.' Then we have problems of access: What places, instruments or models can reveal climate change to us? If it is 'in here,' then we have problems of persuasion: What chains of reference will adequately connect my conviction with yours?.
>
> *(239)*

He points out that Earth-systems scientists have successfully reduced climate change to "an index of global temperature, satellite images of pulsating Arctic Sea ice, a computer-simulated climate of deepening yellows and reds" (239) and that this has made climate change so simplistic and remote as to warrant insufficient attention. Essayist Simon Schaffer points out that "objects become valuable proxies" when experts, perhaps even curators in the case made in this book, "limit meaning and uses," and "tease" climate signals from the artifacts, reducing them to component parts (241). He warns that, perhaps by indexing and calibrating as described earlier, researchers run the risk of turning a human-centered resource into yet another scientific data point. That is not at all the desired result. Humanists must not simply hand their resources to the researchers, back away from the results, and fail to help interpret them for the public.

This chapter examines how local context and personal experiences, and stories, objects, and exhibits can engage the public in understanding the proximity of global climate change; and how crowdsourcing efforts combine the two—increasing access to proxy data while engaging the public in increasing access to climate change data.

Local Context

Climate change is a global event, but we each experience it locally—in the place where we are, or in the places we visit or value. Your experience of climate change

depends upon where you are in the world, in your region, in your community, and in your own evolution of climate awareness and action. As a result, palatable explanations of climate change and solutions to it are completely reliant upon context for acceptance. Some say "the interpretive sciences" and "an interdisciplinarity" are necessary to create the "context for reflection" that can help individuals understand and respond with appropriate solutions (Schipper et al. 2021, 12). If this is correct, then museums are well-positioned to support the development of understanding necessary for solutions. Museums are known for their ability to create those valued connections between objects and ideas, and among people, places, and events. By improving upon the strength of those connections, perhaps museums can stimulate visitor engagement for developing that understanding and creating the engagement that produces those appropriate solutions. Let's examine the variety of paths for those connections for understanding using documentary evidence.

Climate change has been perceived as a "slow-onset crisis," and one that for a large portion of the global population appears to have occurred primarily in faraway places. This is considered a major cause of the resistance to acknowledging and responding to the crisis. A highly summarized behavioral science explanation of what contributes to this climate change communication challenge is that with no imminent or immediate threat to the individual, the brain perceives too few direct impulses for self-defense or self-preservation. When the threat, or the story of the threat, is linked more closely to an individual's lived experience, putting at risk something they value or situating the change within a context they recognize, a curious individual can overcome the temporal and spatial distances that previously kept them from focusing on this issue (Marshall 2014). Museums' interpretation of place-based experiences can help establish a local connection to a global phenomenon. Some museums can fully illustrate a specific aspect of climate change. Some have data that contribute to the story but alone are not proof of a changing climate. It all matters. All those stories can connect our visitors' interests to the phenomenon of climate change.

Experience

Experiences in one's own backyard may provide a closer connection to this global change. Melting glaciers are the iconic image of climate change, but few of us have them on our property. More of us may have experiences with ice on nearby creeks, rivers, ponds, and lakes rather than in glaciers. In Ottawa, Canada, the National Capital Commission is working with a university to identify ways to keep the historic Rideau Canal Skateway open for skating longer each year to respond to climate changes and satisfy public demand. When the 7.8-kilometer community skating destination opened on January 28, 2022, it was the latest opening since 2001. Climate change impacts are reducing the cold conditions that create safe ice (Pringle 2022). A January 2022 evening news piece in the United States highlighted a community ritual at risk due to climate change: pond hockey. Canada and the northern United States have long-standing traditions of ice skating and hockey—outdoors. The news piece focused on amateur, outdoor pond hockey. For 17 years,

the US Pond Hockey Championships have drawn a global set of competitors, but safe skating and high-quality ice days have been declining in Minnesota over the last decades. The trend of fewer outdoor ice-skating days seems to be most dramatic in Toronto with a decrease from almost 60 good days in the 1940s to about 20 now. Outdoor skating and these hockey gatherings are "something that's just embedded with us in this area and in our lives, especially, if you experience it once, you don't want to stop" is what is at risk says a Minnesota interviewee. "It's not about developing [National Hockey League (NHL)] players, so that you're out there and you're just doing your drills and honing all your skills so you can make the NHL. ... you're other messing around with friends" said a hockey player (Yang and Lane, 2022). Both examples are community losses and threats to valued culture.

There are so many ice stories. When Richard Primack visited Walden Pond in Massachusetts on February 20, 2012, he saw an open pond with thinly iced edges. According to Primack, Henry David Thoreau wrote in his journal on February 23, 1854, that the ice covering Walden Pond measured 17 inches thick out in the middle, and a bit more than two years later another entry records both snow and ice totaling 28 inches (Primack 2014, 9). Thoreau kept records of "ice out" at Walden Pond from 1846 to 1860. "Ice out" on the pond averaged April 1 in his time, yet from 1995 to 2009 that average, as measured by the rangers and volunteers at the state park, was two weeks earlier, March 17 (10). Primack's research indicates the average temperatures in February and March in Thoreau's time and when Primack was working in the 2010s. "In Thoreau's time, the temperatures in the Boston area averaged 25 degrees Fahrenheit in January and February, whereas Boston's present temperature averages 28 degrees," which is enough to keep the surface of the entire pond free of ice (11).

The Village of Lake Placid, New York, in the USA, has one of the state's longest records of lake ice coverage. Ice-out contests for the village's Mirror Lake have a long tradition. This smaller lake, adjacent to the much larger Lake Placid is roughly the size of Massachusetts' Walden Pond, but is located farther north and west, 250 miles away. Residents of the Village of Lake Placid, it is said, began recording Mirror Lake conditions in 1903, missing out only a few years since. Now the reporting is kept by the Ausable River Association. On December 20, 2021, it shared this Tweet from Brendan Wiltse:

> Mirror Lake froze overnight. This marks the 5th latest freeze-up on record. The lake initially froze on 12/9, remained frozen for 3 days, and then melted on 12/12. Based on this updated data the lake is freezing on average 17 days later than when record-keeping began in 1903.

Regional climate researchers reported over a decade ago that Mirror Lake has been warming enough in the fall to affect freeze-up dates and create a "roughly two-week shrinkage" in annual ice cover (Stager et al. 2009, 19–20). The author team cited an important record keeper, Jerome Thaler, as a data source contributor but does not explain the source of the data from 1903 until Thaler, born in 1930, began monitoring a National Weather Service Station (*The Journal News*, October 22, 2019). Where

are those records from 1903 to 1950 or so? Who kept them? Is there a ledger, a post-office bulletin board announcement, or notes on the edge of a doorway oriented to the lake? Today, data keepers at the Ausable River Association now monitor the site with video feed, temperature monitors, and access points, but no longer know where the original records were kept (email with the author, January 4, 2022). The Mirror Lake studies continue to capture data but lack the stories that make the information memorable beyond the Twitter feed for non-academics. Surely a local exhibit in that Olympic town (1932 and 1980) might warrant some public interest in climate change as it threatens the future of winter sports, but often so much more is at stake.

In Chapter 2, we examined ice break-up dates as demonstrated by local betting competitions in Alaska. A larger study included those data as well as satellite imagery and community interviews to understand changing ice conditions more completely. Researchers examining river ice freeze-up and break-up in Alaska found that the duration of safe travel on river ice "has declined over the last century and is expected to decline further as the climate continues to warm, thereby presenting new challenges to accessing subsistence resources" and changing lives and lifeways (Brown et al. 2018, 625). Even if mainstream museum visitors may not be able to imagine what these experiences are like for communities far away and dependent upon reliable ice for so much of their individual and cultural survival, local museum programs and exhibits can make connections between local and distant experiences, whether it is shared interest in sport, a shared community experience of betting on ice conditions, testing a nearby lake for ice fishing conditions, or simply as part of discussions at the post office.

Stories

Those sound bites of ice-out bets, pond hockey championships, or skating on the canal through the city can connect people to climate change in ways that instruments and reports cannot.

> The stories of human-nature relationships can increase public investment with larger environmental issues, issues that affect the planet's survival. Museums and historic sites have the ability to introduce the public to this colossal subject and to provide a platform for them to move beyond appreciation of nature toward recognition of their individual roles in preserving their place and taking action to become better stewards of it.
>
> *(Reid and Vail 2019, xiv)*

How many maritime museums are there in the world? Or Coast Guard museums and lighthouses? Or history museums and historic houses in colonial port towns with stories of owners or investors in trading and whaling ships? There must be ships' travel accounts and logs, and family diaries and accounting books, in their collections. Maybe they were a family of fisherpeople making their own income or working for a boat owner. What about in Tribal Museums, and in the climate

knowledge captured in Indigenous stories? Any history or historic house museum collection may have a story of someone who was a hunter who left reports of successes and other observations. Maybe someone served during a civil or international war as a doctor or worked as a military pharmacist and created health and condition records that documented weather. Was the owner of the home a gentleman botanist and his collection is still on display? Was there a woman craving a scientific life who, despite barriers to education and employment, established her own collection of specimens or kept a log of her own observations? Was there a local club of gardeners, naturalists, or hikers who have records over time for a town or region?

These are all people likely to have kept written records that have survived, and their homes and business are places where materials, and shared stories and traditions hold data of conditions from over a century ago, before fossil fuel use began changing the climate. They all could have climate records.

Many sites focus their narrated tours, exhibits, and participatory programs on illustrating the differences between "then" and "now," and on how historians have identified and interpreted those differences. It is a simple step to ask the visitor how they might recognize similar experiences, choice-making, changes, or parallels in their own lives. Marcy Rockman and Jakob Maase, working for the US National Park Service (NPS), have written that every place has a climate story (2017, 107–114). They developed a powerful framework for park rangers interpreting climate change in the nation's 417 units. For those outside the NPS, it is also a valuable tool for public engagement on climate change. Their approach outlines a research path aligning objects and related climate stories through archaeology, earth science, and the historic record. The story aspect helps visitors consider both the impacts of climate change on cultural heritage and the information cultural heritage provides about climate change. The approach tackles communicating the climate stories of the place through one of four themes: Change in the Material World; Change in Experiences and Lifeways; Insights from Past Societies; and Origins of the Modern Climate Situation. Storytelling with documentary proxies for climate change as described in these pages aligns with two of Rockman and Maase's themes, Change in the Material World and Change in Experiences and Lifeways.

It is important to note that these proxies can also support Rockman and Maase's themes Insights from Past Societies and Origins of the Modern Climate Situation. Much of the research for *The Arts and Humanities on Environmental and Climate Change* considered the value of proxy data in adaptation and resilience: past, present, and future response to climate change, particularly as a path to adaptation for living in a changed climate, is a valuable outcome of this research approach. This book does not go that far because first we must finish illustrating how climate change affects all the members of the public, only then may they fully engage in reducing the rate of climate change. The theme, Origins of the Modern Climate Situation, is what some call "smoking guns" of climate change. The research and stories connected to this topic would examine the materials museums already curate to illustrate the significant industrial, capitalistic, material, design, financial, political, and social changes that have driven climate change and developed along with a changing

climate. This is important for explaining how climate change came to be, and therefore how humans might stop contributing to that trajectory. This approach is the usual focus of Anthropocene exhibitions. Perhaps the impact of smoking gun exhibitions can be strengthened if, first, more cultural heritage professionals learn to recognize and share proxy data that document how climate changes are so closely affecting the personal experiences of those visitors.

Objects

"To create the most authentic stories," according to Debra Reid and David Vail, requires "a multidisciplinary approach—more science in the history, more history in the science Incorporating the sciences, history, and the humanities ensures a deep and broad body of evidence about ecological and historical changes over time" (2019, xi). They conclude that "multidisciplinary environment-centric interpretation should appeal to a wide audience" (xi). So what do we think museums should curate that will illustrate climate change in ways that reach increasingly broad audiences? "If we live in times that are sated with apocalypse and drowning in data, what forms of newness, what surprises can Anthropocene narratives deliver?" (Nixon 2017, 27). Humanities collections offer human stories that rise out of the data pools. By curating and co-curating materials in a collection, curators and museum researchers connect sources of information and expertise, with materials and knowledge, and with community members. This is the distinctive public value of cultural heritage in addressing climate change: not everyone is a scientist, but everyone has places, people, and things they love and understand; to connect climate change to what they love and understand makes an abstract and distant topic, finally, relatable, and actionable.

The concepts of interdisciplinary and interconnectedness are common in this work because of the systems-based aspects of climate and the place of humans within the climate system. But in such a complex setting, how can we distill components and illustrate connections that help make sense of it all? The concept of "boundary objects" is at the heart of why collections offer museums a path for public engagement on climate change. Boundary objects connect one of something to another of something by translating one set of characteristics into something compatible with another set of characteristics. They sit in the space between multiple domains, providing bridges, connections, and translations that allow both perspectives to understand the other more fully. Boundary objects inhabit "several intersecting social worlds" (Star and Griesemer 1989, 393). "Boundary objects are both adaptable to different viewpoints and robust enough to maintain identify across them" (387).

Researchers Susan Leigh Star and James R. Griesemer examined the history of the Museum of Vertebrate Zoology at the University of California, Berkley. (Joseph Grinnell was the first director. Recreating his assessments decades later was an early example in this book of using humanities records from museum collections to demonstrate change over time related to climate change.) Their study of Grinnell's approach to creating a collection describes an early version of what is now known as citizen science. Grinnell successfully engaged collectors, cooperating

scientists, administrators, trappers, and other non-scientists in creating a collection and documenting it in a manner that was standardized and reliable for contemporary and future research. He used standardized methods of collecting, preserving, labeling specimens, and taking field notes, that captured critical data but in a manner that very disparate participants could tolerate and complete successfully (Star and Griesemer 1989, 406). When faced with starting a natural history museum, and actively expanding upon an existing private collection, Grinnell needed to mobilize an army of helpers. This meant engaging enough people when so few would have training in identifying and collecting specimens. How would he ensure that they collected the right materials in the right way, and kept collecting for him until he had enough for his museum? In planning his helpers' work and process, Grinnell took care to be sure "their pleasure was not impaired—the basic activities of going on camping trips, adding to personal hobby collections and preserving California remained virtually untouched" while also satisfying the museums' needs (407). As the different types of helpers fanned out to collect specimens and describe conditions, their varied interests, needs, and skills all converged in the process of collecting, identifying, and recording the materials that would become a museum collection. The objects they collected, and the documentation they prepared, became boundary objects, acting as anchors or bridges connecting them in this effort (414).

All the documents described in this climate change research are also boundary objects: the ships' logs, the farmer's almanacs, and the memories of being able to walk all the way across the pond at Christmas. Museums can use their proxy data to connect with all the different kinds of researchers, universities, volunteers, and visitors to come together around climate change research.

Exhibits

The special value of exhibits that incorporate climate change evidence and human response is that they provide the settings where visitors and objects can connect. These spaces bring together people, data, and collections in ways that "collapse past and present, near and far ... They invite understanding of how localized particularities become interwoven with broad geographies ..." (Newell et al. 2017, 5). Brad Washburn, founder of the Museum of Science Boston, captured images of Alaska's glaciers in the 1930s and 1940s. The museum was interested in using those images in an exhibit to compare them with more recent ones to illustrate a changing climate. Early 21st-century photography of those same glaciers by David Arnold, a member of the museum staff 65 years later, provides a dark story of loss over time (Schoenfeld 2006). The comparison of images of the Mendenhall and Hughes Miller Glaciers over that timespan shows a dramatic change. Arnold "was amazed at how far [Mendenhall] had retreated." The 2006 image "shows a smaller, thinner Mendenhall. Its crumpled, white image is much less of a presence than in Washburn's earlier image" (Schoenfeld 2006).

Natural history museums can be considered a transitional space for the museum sector's evolving acceptance of climate change as an interpretive responsibility.

What was at first the purview of science museums like Boston's quickly moved to include natural history museums. Around the world, these institutions have been hosting Anthropocene exhibits at least since 2013 (Oliviera et al. 2020, 335). What many call the complexities of the topic can be simply described as interconnections. Any museum can address the Anthropocene in ways distinctive of its "specific collections and curatorial research perspectives" (336). The complexity of the Anthropocene and the interconnectedness offer many more storytelling and engagement avenues than the visitor has come to expect. This is an invitation to museums to activate humanities collections, research, and perspectives to bring the global climate change story right to the visitor's personal experience. Just as the natural history museum could bring the humanities into its story, the history and cultural museum can and should bring the sciences into their work to tell these complex, far-reaching stories in relatable ways.

Chapter 2 described the two iconic *environmental* research projects that involved the Field Museum's collections: egg specimens to document the impacts of DDT and bird specimens to research changes in air pollution due to public policies. The New England region brings us the two iconic *climate change* research projects involving humanities proxies: the journals of Henry David Thoreau in Concord, Massachusetts, and the logbooks of the Champlain Society, on Mount Desert Island, in Maine.

Early Spring, *the Concord Museum*

Let's continue to examine biologists Richard Primack and Abe Miller-Rushing's work in Concord, Massachusetts, introduced in Chapter 3. They collected historical records of bird presence and plant bloom times and used those records to document a changing climate. *Early Spring: Henry Thoreau and Climate Change*, was an extraordinary exhibit at Massachusetts' Concord Museum (2013). It opened in 2013 and continues online. Its humanities backbone is Henry David Thoreau's journal from 1837 to 1861: "a perfect bridge from past to present, between history and science, and a connection to anyone with a backyard, front path, or nearby park" (Sutton 2015, 141). Richard Primack's work with his teams of students and colleagues is an excellent illustration of the collaborative thinking required to examine such a complex topic as climate change. Primack and Miller-Rushing open their 2012 article in *BioScience*, nearly a decade into their research, with this abstract:

> Historical records are an important resource for understanding the biological impacts of climate change. Such records include naturalists' journals, club and field station records, museum specimens, photographs, and scientific research. Finding records and overcoming their limitations are serious challenges to climate change research. In the present article, we describe efforts to locate data from Concord, Massachusetts, and provide a template that can be replicated in other locations. Analyses of diverse data sources, including observations made in the 1850s by Henry David Thoreau, indicate that climate change is affecting the phenology, presence and abundance of species in Concord.

Despite recent work on historical records, many sources of historical data are underutilized. Analyses of these data may provide insights into climate change impacts and techniques to manage them. Moreover, the results are useful for communicating local examples of changing climate conditions to the public.

(Primack and Miller-Rushing 2012, 170)

Henry David Thoreau was a neighbor, friend, and fellow author of the literary elite in 19th-century Concord, Massachusetts, alongside Ralph Waldo Emerson, Louisa May Alcott, and Nathaniel Hawthorn. Today his *Journal* and writings are known worldwide. Botanists, writers, historians, naturalists, wanderers, and so many students worldwide read his works. Primack and Miller-Rushing explain that, in his explorations of what is now the Walden Pond State Park and the lands surrounding it and this New England town, Thoreau "made observations of first flowering dates for over 500 species of wildflowers in Concord from 1851 to 1858 … [and he] also observed and recorded the dates of initial leaf out for trees and shrubs and the first sightings of migratory birds in springtime" (171–172). And yet Thoreau was not the sole historical source for Primack and Miller-Rushing: a local botanist Alfred Hosmer recorded flower dates of 600 species in Concord in 1878 and then from 1888 to 1902. This data—after all the hard work of organizing and understanding it—was contrasted with Primack's and Miller-Rushing's purpose-built modern dataset. Rather than compare this material to digitized, broadly applicable modern data, Primack and Miller-Rushing established their own current comparative baseline. (This ensured a comparison not of historic Concord to available datasets for modern New England, but of historic Concord to modern Concord.) They identified 43 species *in situ* that both Hosmer and Thoreau had documented in Concord. This is a fraction of the 500 in Thoreau's *Journal*. Primack and Miller-Rushing found that when they calculated the average flowering time across 43 common species of the Thoreau, Hosmer, and Primack/Miller-Rushing data, they were flowering three full weeks earlier than in Thoreau's time (Primack 2014, 48–50). Primack and Miller-Rushing's history of the research challenges is a textbook for learning to recognize and use these data, and to understand the local environmental degradation and changes that can influence the dataset: climate is not the only change over time.

Working with Primack, the Concord Museum developed the exhibit "Early Spring: Henry Thoreau and Climate Change," bringing climate change home to suburban Massachusetts. Primack wrote that "Thoreau had prepared tables precisely documenting the annual flowering times of over three hundred plant species. Species occupied row after row on successive pages of surveyor's paper, with years listed in the column heads at the top of each sheet. Thoreau had created these tables by extracting data from all of his journals" (Primack 2014, 6). Concord Museum's Curator David F. Wood says that these pages were his favorite of the exhibit, comparing them to an extraordinarily early version of what today we would recognize as an Excel sheet on the computer. Thoreau created them so he could easily look up a plant and a date, and know where and when to look for the first blooms in Spring (conversation with the author, February 14, 2022) (Figures 4.1–4.5).

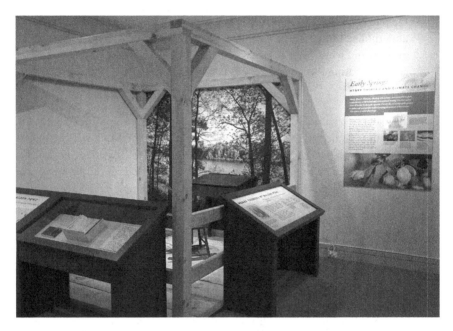

FIGURE 4.1 *Early Spring* exhibition at the Concord Museum.
Courtesy of the Concord Museum, Photograph by Cherrie Corey.

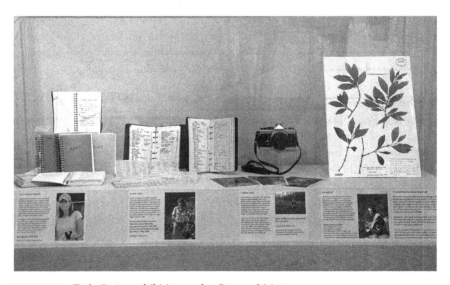

FIGURE 4.2 *Early Spring* exhibition at the Concord Museum.
Courtesy of the Concord Museum, Photograph by Cherrie Corey.

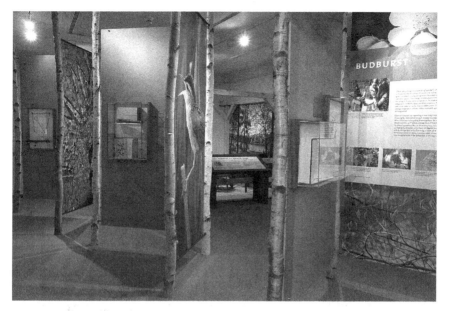

FIGURE 4.3 *Early Spring* exhibition at the Concord Museum.
Courtesy of the Concord Museum, Photograph by Cherrie Corey.

The chart and the journal entries were "a perfect window into the local ecology of eastern Massachusetts a century and a half ago" (Primack 2014, 5–6). Consider pink lady's slipper, a distinctive flower common in Concord's woods. Thoreau recorded them in 1853 as flowering on May 20, with May 24 and 30 in subsequent years. Primack writes that

> for Thoreau, this was a late May species. Today if I went looking for the first flowers of the pink lady's slipper orchid on May 20, I would be too late—In the 160 years since Thoreau recorded his observations ... the pink lady's slipper orchid in Concord has shifted its first flowering time ... three weeks earlier

Apple trees now flower an average of two-to-four weeks earlier (45–47). Today, plants are flowering "by about 1.7 days" earlier per degree of Fahrenheit temperature change (150). Primack wrote that "When a historical perspective is combined with modern observations, one thing becomes clear: climate change has come to Walden Pond" (ix).

In addition to the exhibit, the museum's education staff created a phenology garden and continue to use it nearly a decade later for school programs visiting the exhibit. The extensive website continues to offer links to related articles, audio clips of nature sounds, websites for additional research, and stories about the researchers from Boston University, offering multiple paths for engagement. The lesson plans and family activities encourage nature journaling, and link to Project

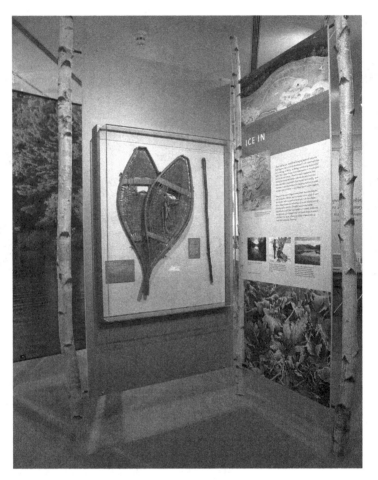

FIGURE 4.4 *Early Spring* exhibition at the Concord Museum.
Courtesy of the Concord Museum, Photograph by Cherrie Corey.

Budburst, a crowdsourcing activity for documenting bloom times just as Thoreau did. Visitors to the exhibit and the website learn about Thoreau and other more recent Concordians who contributed to the environmental record-keeping tradition. They are invited to see themselves as contributors to the research on climate change, and were invited to be part of that special group, the long line of citizen scientists, professional and amateur historians, photographers, ornithologists, ecologists, and botanists in Concord's history, whether or not they saw themselves as scientists (Sutton 2015, 143).

Landscape of Change, Mount Desert Island Historical Society

Another New England project is currently underway that extends the format of the work done in Concord. The primary difference is that the project originated

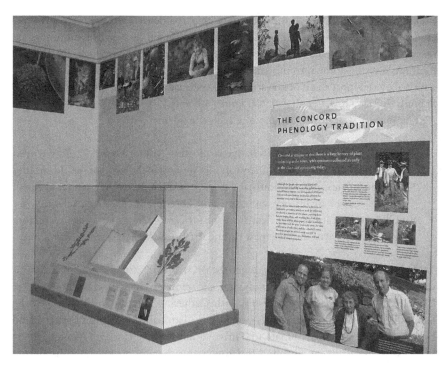

FIGURE 4.5 *Early Spring* exhibition at the Concord Museum.
Courtesy of the Concord Museum.

within the Mount Desert Island Historical Society (MDIHS), rather than an out-side academician, and from materials in its own collections. MDIHS' Landscape of Change is the epitome of collections' use as climate proxies for climate change and as vehicles of public engagement.

The small island is in Downeast Maine in the Northeast of the United States, in the Atlantic Ocean. It is just 280 square kilometers, with a history of year-round residents earning a living from the sea, and summertime residents, particularly from Boston, New York, and Philadelphia, coming to enjoy the wildness and beauty of the region. Some of those visitors were members of the self-designed Champlain Society, "an adventurous and curious group of young men from Harvard [who] spent summers on the island exploring and documenting the natural world" (Landscape of Change 2021). They left behind not only a legacy of data but also of protecting open space, leading to the creation of Acadia National Park, today the seventh busiest national park in the United States (Schmitt 2014).

The MDIHS is the steward of the journals of the Champlain Society, a treasure trove of documentary proxy data: 19 notebooks of more than 1000 pages covering 1880–1893 (20). The students divided themselves into natural history "departments," each with a focus on a specific area of study: fishes, mammals, birds, and insects; meteorology, botany, and geology. They recorded their experience with photography, and their observations in logbooks that documented their daily activities and

findings. At the end of each summer, they prepared department reports and delivered them at Society gatherings during the fall (Bench 2021). This summertime record-keeping created a baseline valuable for comparison today. Since the historic locations are well-known to modern islanders and summer visitors, it has been relatively easy to repeat these observations 140 years later (Landscape of Change 2021; Schmitt 2021, Schmitt et al. 2019) (Figures 4.6 and 4.7).

The project website, Landscape of Change, explains

> To understand how climate change is affecting Mount Desert Island we need to look to the past. Our ancestors documented the natural world around them in stories, reports, journals, diaries, and letters, which are cared for in the collections of history museums and libraries. Increasingly, scientists are pulling observations and data from historic records to get a clearer picture of the natural world of the past to understand how the present is changing.

To help answer the question of whether or not this historic information was valuable to understanding environmental and climate change on Mount Desert Island, MDIHS formed a partnership with Catherine Schmitt and the staff at the Schoodic Institute along with staff from Acadia National Park, Mount Desert Island Biological Laboratory, A Climate to Thrive (a nonprofit alliance on Mount Desert Island working to bring all four MDI towns together for an engaged sustainable future), and the College of the Atlantic.

Working together over the past two years, the partners digitized and mapped the historic data from a variety of surveys and inventories of insect and bird species on the

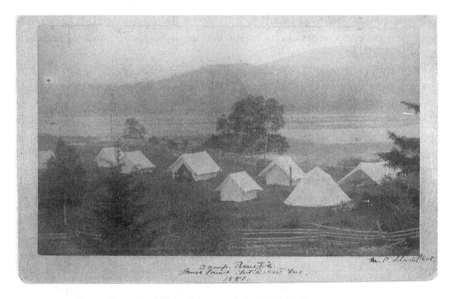

FIGURE 4.6 Camp Pemetic, 1881, photograph by M.P. Slade.
From the collection of the Mount Desert Island Historical Society.

FIGURE 4.7 Weather records taken by members of the Champlain Society July 13 and 14, 1880. In the collection of the Mount Desert Island Historical Society. Photograph by Jennifer Steen Booher.

island over 140 years, including Champlain Society data. Additional data come from instrumental recording stations introduced after 1893, providing continuous information from the days of the Champlain Society forward. Raney Bench, the Historical Society Director, explains that they "started with historic records that had the best and easiest observations to pinpoint in place and time, which were birds and insects, weather records, and sea water temperature" (Landscape of Change 2021; interview with Bench, January 6, 2021). To complement the data, they also documented the biological history of the island using observations of butterflies and moths by Roland Thaxter, specimens in the Harvard Museum of Comparative Zoology, and other resources for this region of Maine known as Acadia (Landscape of Change 2021).

Meanwhile, the University of Maine has analyzed climate data for the area that shows that the average temperature in coastal Maine has warmed by 3.4 degrees Fahrenheit (°F) (Fernandez et al. 2020, 8). Around the state, ice-out on lakes occurs earlier from one day to three weeks (9). Catherine Schmitt, a member of the Landscape of Change project contributed to that report. This overlap benefits both projects, and Schmitt is working to apply some of the report's findings to Mount Desert Island.

MDIHS and the Schoodic Institute have been conducting much of the work with the assistance of citizen scientists. Visitors to the island have been invited to revisit the historic datasets and the modern locations to make their own observations, sharing them through the app-based tools iNaturalist and eBird to help document "changing land and sea-scapes" on the island (Landscape of Change 2021). There is years' more work to be done, but Bench has personally seen the effects:

she says people who may or may not engage in climate change personally or politically can see that it is happening right here in a place they love, and that is more than enough to get their attention and earn their support. It's another example of how the value of a place can drive public engagement in positive ways. Schmitt says, "The climate change message is often negative, and leaves people feeling helpless. Participating in science, in paying attention to the natural world, is something everyone can do, and in the process be inspired by the beauty and wonder of the world around us while also documenting change" (email with the author, March 25, 2022). Citizen engagement through cultural heritage-based activities helps raise awareness on climate change and its effects, often attracting supporters and always deepening the research (Dawson et al. 2017).

Crowdsourcing and Citizen Science

The excellent examples of the research projects and related exhibits for Thoreau and *Early Spring*, and The Champlain Society and Landscape of Change stand alone as fully realized public engagement using documentary proxy data for climate change. Though likely this singularity has many explanations, one is the persistent gap between the scientists who *need* data and the museum workers who know there *is* data in collections. Somehow the space between those two domains remains unbridged. Very often the primary barrier is an issue of access, both intellectual and physical. Researchers on both sides simply do not know what and how much there is to be mined for climate research and engagement. Museums can change this paradigm by choosing to expand this access and build their participation in the climate evidence discussions through cooperative efforts of distributed helpers through crowdsourcing.

Bench notes the difference between ownership and stewardship. She points out the commitment at MDIHS to a stewardship role that compels the organization to provide free access, "in as many ways possible without hurting the collection. MDIHS is actively sharing [the collections it cares for]—maybe even aggressively sharing" those collections (email with the author, March 22, 2022). That final point is revolutionary: aggressively sharing collections. What a radical and entirely necessary approach.

Crowdsourcing may offer solutions. It is a critical path to digitizing additional content for use in programs, exhibits, and research in a timely manner. Without crowdsourcing, Schmitt says that transcribing and digitizing the journals of the Champlain Society took ten years, *then* they could launch Landscape of Change (email with the author, March 25, 2022).

By allowing individuals to access material online, and transcribe it for researchers to analyze, museums may be able to unlock more of their records and make them available to climate researchers. Curators may be able to accelerate their transcription projects using the Zooniverse online platform, or something similar, to engage visitors in transcribing data, using the results in the future for exhibits and programs. Currently, the two most common areas for crowdsourced transcription projects

have been weather and botanical specimens but there are unlimited approaches to gathering data from helpful public observers, and unlimited topics for attracting volunteers with varying interests. Here we will note crowdsourced data related to ice, weather, water, and botanicals for inspiration on both sides of the equation: data access and/or public engagement. The unifying feature in all of these is the data captured by people, whether recording tides or weather as part of their jobs, collecting and documenting specimens as a hobby, or celebrating community sports.

Ice

A researcher at Wilfrid Laurier University in Canada helped create RinkWatch.org to crowdsource information about pond ice conditions as they relate to amateur hockey. The project doubled as a public engagement approach for discussing climate change. McLeman and his colleagues thought that with weather, hockey, and skating as Canadians' favorite topics, "if we could come up with an environmental science project that links those two things to a broader understanding of climate change, then we'd have something." They examined contributed data on "skateability trends" with historical data for Boston, Chicago, Detroit, New York, Montreal, and Toronto. The conclusion was that in all six cities the number of days for good skating has been falling since the 1940s. Toronto exhibited the greatest change, dropping from 60 to 20 days, two years ago (Yang and Lane 2022).

Weather Rescue at Sea

Weather Rescue at Sea is a citizen science approach that illustrates a valuable bridging activity: transcription of ships' logs for historical observations. There are far fewer monthly observations from the 1860s and 1870s of ships traveling the Atlantic, Indian, and Pacific oceans than from the rest of the 19th century. The gap can be sufficiently filled through data in the archives at the United Kingdom's Hydrographic Office. About 15% of the work had been done at the time of this writing. Anyone, from their home, school, or museum computer terminal can access images of the logbooks and record the image information, turning it into searchable data that scientists can use to understand weather patterns more completely around the world back to the 1780s. Volunteers can choose a weather parameter (wind direction, wind force, navigation, sea and air temperature, and barometric pressure) to transcribe. The site provides an overview description of the organization of information on the historic page in the image, and a tutorial for practice before beginning. This improves volunteer comfort, confidence, and accuracy, improving the reliability of researchers. This is still purely academic research and still underway.

TEMPEST Database

The TEMPEST database is another Zooniverse project. This online repository of the United Kingdom's extreme weather events currently contains about 18,000

records across 400 years. Its sources include monthly mean temperatures reaching back to 1659 and daily readings from 1772, much of the early data being collected by Gordon Manley in the 1950s and 1970s using manuscript data recording instrumental readings, many by dedicated individuals centuries ago (Veale et al. 2017). He sourced his materials from the Bodleian Library, British Museum, Guildhall Library, and Royal Society's Library (Manley 1974). A precursor to the TEMPEST database is "Old Weather," a Zooniverse project launched in 2010 to collect data from the 4000 East India Company logbooks mentioned in Chapter 3. This crowdsourcing project won the Royal Meteorological Society's IBM award for "Meteorological Innovation that Matters" in 2013 (Veale et al. 2017, 4). This too is mainly academic research and still underway.

United Kingdom Tidal Data

In one year, 3,814 Zooniverse volunteers transcribed all the data from tide height records at George's Dock in Liverpool and nearby Hilbre Island Lifeboat Station from digitized records (Zooniverse project website, February 6, 2022; Sommer 2021). At the time of this writing, the transcription is just completed and the research conclusions are not yet available.

Angling for Data on Michigan Fishes

This Zooniverse project has volunteers transcribing data from survey cards with historical fish population diversity, abundance, and growth data from Michigan lakes as originally collected and reported by state employees. It is a partnership between the Michigan Department of Natural Resources and the University of Michigan, including its Museum of Zoology. The surveys were begun in the 1880s and conducted into the early 1890s, then restarted in the 1920s and continued by various agencies. Now the information is being transcribed to provide long-series data for studying the health of fish populations and their response to changing conditions. The researchers need to understand the different approaches historically to capturing and measuring fish to make the data comparable and therefore reliable for study. The researchers will be able to pair the survey data with the fish specimens kept at the museum, building a far better understanding of fish populations over time, and how they are likely to respond to future conditions (Zooniverse website, February 2022).

Botanical Data

Primack and Miller-Rushing have argued that gardens are uniquely placed to research and respond to climate change because of the quality, specificity of items, and the geographic and taxonomic range of these collections. They argue that gardens contain key data about the impact of anthropogenic change in the records that show the effect of temperature change on flowering time and leaf-out. Of particular value are their herbarium collections. These "contain records of past and present

plant distribution, biodiversity, phenology and bioclimatic data" (Willoughby 2017, 189–190). Two thousand "crowdsourcers" helped Harvard University researchers examine 7,000 herbarium specimens representing 30 flowering species over 120 years of records from the eastern United States. They used the tool *CrowdCurio*, a crowdsourcing, image annotation tool specifically used in examining herbarium collections to conduct phenological studies. The result revealed plants' responses to climate change within regions, understanding influences and revealing patterns helping to understand and "ultimately … [forecast] the impacts of climatic change on the structure and function of ecosystems" (Park et al. 2018, 1). The researchers compared the use of "expert" and "non-expert workers" in the process and discovered no statistical difference in work accuracy but a significant savings in cost despite non-expert workers being far less time-efficient than experts (Willis et al. 2017, 479).

The Palaeontologist and the Gingko

Another Zooniverse project is the citizen science portion of "Fossil Atmosphere," a project "to refine stomatal index of Gingko leaves." A Gingko leaf has stomata and epidermal cells that correspond to CO_2 concentration. Examining dated samples and counting the stomata helps refine the index proxy for using these cells on the leaf surface for estimating CO_2 levels in the atmosphere (Soul et al. 2018, 375). But someone needs to count the stomata. An advantage to the public viewing and reporting on images of these specimens is that it expands the number of researchers able to access the collections while avoiding the transport or handling of the fossils other than for the imaging—which is important for recordkeeping and likely necessary for basic management. The same can be said of manuscripts or humanities resources being imaged for crowdsourced annotation. Some herbarium specimens and the modern ones used for this project are part of the Smithsonian's National Museum of Natural History (376).

The Future of Climate Change Representation

The apparent expansion of crowdsourcing for climate data, in museum collections and other sources, suggests an imminent shift in access, and a future of powerful discoveries and knowledge-sharing around climate change. Within many museum collections, curators can find and share information with researchers and contributing to their broader databases. They also can share scientific and cultural information for meaningful engagement with the public. In both *Early Spring* and Landscape of Change, diaries of amateurs led to complex studies across communities, involving hundreds of participants. Each of the other examples here mixes science and humanities in ways that enrich the science and broaden public engagement and awareness. There is room for much, much more of this.

In this book, the focus is on establishing humanities collections' proxy role in illustrating a changed climate. Those stories help the public "take responsibility for and respond to their changed world" (Nixon 2017, 24). Hopefully, there will soon

be no need to "prove" climate change, and instead these resources can be used to build exhibits, create programs, and tell stories of how communities have used this knowledge to adapt to climate change while working to reverse it.

References

Bench, Raney. 2021. "Citizen Scientists Needed to Help Document Climate Change." Press release, shared with the author, April 19, 2021.

Brown, Dana R. N., Todd J. Brinkman, David L. Verbyla, Caroline L. Brown, Helen S. Cold, and Teresa N. Hollingsworth. 2018. "Changing River Ice Seasonality and Impacts on Interior Alaskan Communities." *Weather, Climate, and Society* 10, no. 4 (October 1): 625–640. https://doi.org/10.1175/WCAS-D-17-0101.1

Concord Museum. 2013. "Ice Out." Label text, *Early Spring: Henry David Thoreau and Climate Change*, April 12–September 15, 2013. https://concordmuseum.org/online-exhibition/early-spring-henry-thoreau-and-climate-change/seasonal-cycles-ice/

Dawson, Tom, Joanna Hambly, and Ellie Graham. 2017. "A Central Role for Communities: Climate Change and Coastal Heritage Management in Scotland." In *Public Archaeology and Climate Change*, edited by Tom Dawson, Courtney Nimura, Elías López-Romero, and Marie-Yvane Daire, 1st ed., 23–33. Philadelphia: Oxbow Books.

Diemberger, Hildegard, Kirsten Hastrup, Simon Schaffer, Charles F. Kennel, David Sneath, Michael Bravo, Hans-F. Graf, et al. 2012. "Communicating Climate Knowledge: Proxies, Processes, Politics." *Current Anthropology* 53, no 2 (April): 226–244. http://doi.org/10.1086/665033

Fernandez, Ivan, Sean Birkel, Catherine Schmitt, Julia Simonson, Brad Lyon, Andrew Pershing, Esperanza Stancioff, George Jacobson, and Paul Mayewski. 2020. *Maine's Climate Future 2020 Update*. Orono, Maine: University of Maine. https://climatechange.umaine.edu/wp-content/uploads/sites/439/2020/02/2020_Maines-Climate-Future-508-ADA-compliant.pdf

Hartley, Mitchell (@DocHarleyMD). 2021. "Yesterdays #storm in Sydney stripped North Curl Curl Beach of its sand. What it revealed was an amazing time capsule of etchings written by people following past storm events. A thread 1/7." Twitter, August 26, 2021. https://twitter.com/DocHarleyMD/status/1430810496035291140

Hartley, Mitchell D., Ian L. Turner, Andrew D. Short, and Roshanka Ranasinghe. 2009. "Interannual Variability and Controls of the Sydney Wave Climate." *International Journal of Climatology* 30, no. 9 (June): 1322–1335. https://doi.org/10.1002/joc.1962

Landscape of Change Public Story Map. 2021. "Explore How Climate Change Is Affecting Birds, Pollinators, Frenchman Bay, the Climate of Mount Desert Island, and How You Can Get Involved!" August 10, 2021. https://storymaps.arcgis.com/stories/dcb1b25509e64b628ce40c5ae7ed4675

Manley, Gordon. 1974. "Central England Temperatures: Monthly Means 1659 to 1973." *Quarterly Journal of the Royal Meteorological Society* 100, no. 425 (July): 389–405. https://doi.org/10.1002/qj.49710042511

Marshall, George. 2014. *Don't Even Think About It: Why Our Brains Are Wired to Ignore Climate Change*. New York: Bloomsbury USA.

Newell, Jennifer, Libby Robin, and Kirsten Wehner, eds. 2017. *Curating the Future: Museums, Communities and Climate Change*. London: Routledge.

Nixon, Rob. 2017. "The Anthropocene and Environmental Justice." In *Curating the Future: Museums, Communities and Climate Change*, edited by Jennifer Newell, Libby Robin, and Kirsten Wehner, 23–31. London: Routledge.

Oliveira, Gil, Eric Dorfman, Nicolas Kramar, Chase D. Mendenhall, and Nicole E. Heller. 2020. "The Anthropocene in Natural History Museums: A Productive Lens of Engagement." *Curator* 63, no. 3 (September 1): 333–351. https://doi.org/10.1111/cura.12374

Park, Daniel S., Ian Breckheimer, Alex C. Williams, Edith Law, Aaron M. Ellison, and Charles C. Davis. 2018. "Herbarium Specimens Reveal Substantial and Unexpected Variation in Phenological Sensitivity across the Eastern United States." *Philosophical Transactions of the Royal Society B* 374, no. 1763 (November 19): 20170394. https://doi.org/10.1098/rstb.2017.0394

Primack, Richard B. 2014. *Walden Warming: Climate Change Comes to Thoreau's Woods.* Chicago: The University of Chicago Press.

Primack, Richard B., and Abraham J. Miller-Rushing. 2012. "Uncovering, Collecting, and Analyzing Records to Investigate the Ecological Impacts of Climate Change: A Template from Thoreau's Concord." *BioScience* 62, no. 2 (February): 170–181. https://doi.org/10.1525/bio.2012.62.2.10

Pringle, Josh. 2022. "NCC Looks for Ways to Extend Skating Season on the Rideau Canal Each Winter." *CTV News*, January 22, 2022. https://ottawa.ctvnews.ca/ncc-looks-for-ways-to-extend-skating-season-on-the-rideau-canal-each-winter-1.5750453

Reid, Debra A., and David D. Vail. 2019. *Interpreting the Environment at Museums and Historic Sites.* Lanham, Maryland: Rowman and Littlefield.

Rockman, Marcy, and Jakob Maase. 2017. "Every Place Has a Climate Story: Finding and Sharing Climate Change Stories with Cultural Heritage." In *Public Archaeology and Climate Change*, edited by Tom Dawson, Courtney Nimura, Elías López-Romero, and Marie-Yvane Daire, 1st ed., 107–114. Philadelphia: Oxbow Books.

Schipper, E. Lisa F., Navroz K. Dubash, and Yacob Mulugetta. 2021. "Climate Change Research and the Search for Solutions: Rethinking Interdisciplinarity." *Climatic Change* 168, no. 18 (October 18): 1–11. https://doi.org/10.1007/s10584-021-03237-3

Schmitt, Catherine. 2014. "Visionary Science of the 'Harvard Barbarians'." *Chebacco* XV: 17–31.

Schmitt, Catherine, ed. 2021. *Chebacco: The Journal of the Mount Desert Island Historical Society,* XXII. Mt. Desert, Maine: Mount Desert Island Historical Society.

Schmitt, Catherine, Tim Garrity, Maureen Fournier, and Caitlin McDonough MacKenzie. 2019. "The Champlain Society and the Origins of Acadia National Park." Case study in Chapter 10 of *Interpreting the Environment at Museums and Historic Sites*, by Debra A. Reid and David D. Vail, 137–142. Lanham, Maryland: Rowman and Littlefield.

Schoenfeld, Ed. 2006. "Photos Capture Melting Splendor of Alaska's Glaciers." NPR Radio, October 23, 2006. https://www.npr.org/templates/story/story.php?storyId=6369091

Sommer, Lauren. 2021. "How Fast Are Oceans Rising? The Answer May Be in Century-Old ShippingLogs."*NPR Radio*, March 1, 2021. https://www.npr.org/2021/03/01/959600735/how-fast-are-oceans-rising-the-answer-may-be-in-century-old-shipping-logs

Soul, Laura C., Richard S. Barclay, Amy Bolton, and Scott L. Wing. 2018. "Fossil Atmospheres: A Case Study of Citizen Science in Question-Driven Palaeontological Research." *Philosophical Transactions of the Royal Society B* 374, no. 1763 (November 19): 20170388. http://doi.org/10.1098/rstb.2017.0388

Stager, J. Curt, Stacy McNulty, Colin Beier, and Jeff Chiarenzelli. 2009. "Historical Patterns and Effects of Changes in Adirondack Climates Since the Early 20th Century." *Adirondack Journal of Environmental Studies* 15, no. 2 (January): 14–24. https://digitalworks.union.edu/ajes/vol15/iss2/5/

Star, Susan Leigh, and James R. Griesemer. 1989. "Institutional Ecology, 'Translations' and Boundary Objects: Amateurs and Professionals in Berkely's Museum of Vertebrate Zoology, 1907-39." *Social Studies of Science* 19, no. 3 (August 1): 387–420. https://doi.org/10.1177/030631289019003001

Sutton, Sarah. 2015. *Environment Sustainability at Historic Sites and Museums.* Lantham, MD: Rowman and Littlefield.

Veale, Lucy, Georgina Endfield, Sarah Davies, Neil Macdonald, Simon Naylor, Marie-Jeanne Royer, James Bowen, Richard Tyler-Jones, and Cerys Jones. 2017. "Dealing with the Deluge of Historical Weather Data: The Example of the TEMPEST Database." *GEO: Geography and Environment* 2, no. 2 (August 17): 1–16. https://doi.org/10.1002/geo2.39

Willis, Charles G., Edith Law, Alex C. Williams, Brian F. Franzone, Rebecca Bernardos, Lian Bruno, Claire Hopkins, et al. 2017. "*CrowdCurio*: An Online Crowdsourcing Platform to Facilitate Climate Change Studies Using Herbarium Specimens." *New Phytologist* 215, no. 1 (April 10): 479–488. https://doi.org/10.1111/nph.14535

Willoughby, Sharon. 2017. "Shaping Garden Collections for Future Climates." In *Curating the Future: Museums, Communities and Climate Change*, edited by Jennifer Newell, Libby Robin, and Kirsten Wehner, 181–191. London: Routledge.

Yang, John, and Sam Lane. 2022. "Unpredictable Weather Impacts Long-Standing Traditions on Outdoor Rinks." *PBS Newshour*, January 31, 2022. https://www.pbs.org/newshour/show/unpredictable-weather-impacts-long-standing-traditions-on-outdoor-rinks

5
THE VALUE OF CULTURAL HERITAGE TO CULTURAL CLIMATE DIPLOMACY

When a climate heritage professional looks across the community, city, region, nation, or world, they see all the things that a scientist or politician or visitor or resident sees: fields and farms, old and new buildings, roads and rivers, forests and lakes, and people and other creatures. They also see, with their climate change eyes, acres of heritage landscapes that are carbon sinks, storm surge buffers, and cooling spaces alongside urban heat islands. They see fields where a Native nation has brought back Bison for traditional and regenerative agriculture. They see rivers that generations of people and creatures have depended upon and still do today. They see lakes or ponds or shorelines that are special places remembered from their childhoods or that have helped communities thrive for centuries. These everyday places are important to the many people who notice them and are connected to them, whether or not each person who values them would recognize them as cultural resources. Those values are the meeting points between those who care *for* cultural resources and the many publics who care *about* them.

Documentation of change that is affecting and will affect those places can help make the connection between what people care about and the climate change that is all around us. Shared values for cultural heritage are a path for establishing a shared understanding of the necessity to address the climate crisis whether neighbor to neighbor over a fence, or nation to nation across political borders. Commitment to tackling climate action hinges on how our values align with the conservation of the planet, and with the health and wellbeing of everything on it.

The 2009 Salzburg Declaration on the Conservation and Preservation of Cultural Heritage was written by representatives of 32 nations. It recognizes

> that our global cultural heritage strengthens identities, well-being, and re-spect for other cultures and societies. ...cultural heritage is a powerful tool to

DOI: 10.4324/9781003044765-6

engage communities positively…, creates an appreciation of diverse cultural heritage and its continuity for future generations, and promotes mutual understanding between people, communities, and nations.

That statement was created with the goal of global understanding and well-being reinforced through cultural heritage. Not every person will value heritage equally, or value each other's heritage, but every community and every nation has a cultural heritage as the foundation of its own identity. They have a cultural heritage they wish to protect and share.

Cultural identity is on display at the opening of every Olympics. When leaders come together from around the world, they meet at each country's cultural institutions: palaces for treaties (Palace of Versailles, WWI, 1919), public gardens for global summits (Phipps Conservatory and Botanical Gardens, G-20 Summit, 2009), and art galleries for United Nation's Conferences of the Parties (Kelvingrove Art Gallery & Museum in Glasgow, COP26, 2021). They always showcase culture when they host visitors. On the strength of this and the art, museum, and nature examples following, cultural heritage professionals can and should make the case that documenting and responding to the effects of climate change both requires and supports international engagements and diplomacy (Hambrecht and Rockman 2017). These basic values can be a platform for more conversations, for diplomacy, and for creating commitments to tackling climate.

Cultural Diplomacy as a Resource for Climate Diplomacy

Chapter 4 examined how documentary climate proxies are boundary objects enabling people from different backgrounds to meet around an experience, a memory, or an object of interest or importance to each. The object is an intersection that allowed peoples' differences and similarities to coexist, even connect. Cultural heritage resources are those boundary objects, making cultural diplomacy a resource for climate diplomacy.

Nations have used, and continue to use, culture as a diplomatic tool. Kathleen Berrin has researched past US cultural diplomacy through the orchestration of international art exhibits before, during, and after the Second World War. Natalia Grincheva has researched modern museum construction and investment as global diplomatic assets. Similarly, Raf de Bont has researched historic international diplomacy through natural lands and species conservation. Each provides precedents that support cultural heritage as a diplomatic resource.

Today we see cultural diplomacy in action as countries and cultural institutions repatriate stolen art and cultural artifacts, making a show of how they have cared for the objects and, with great ceremony, are now returning them to their rightful homes, righting a past wrong with present actions. Often this involves government officials and ceremonies. These are all diplomatic activities, official or not. Cultural heritage landscapes, structures, documents, and intangible cultural heritage share this diplomatic capacity with art, nature, and museums: they each have parallels among countries, with people everywhere who care for and about them.

Berrin, in her study of art exhibitions as diplomacy for the USA before, during, and after the Second World War illustrates the value of a nation's art as diplomatic resources. The art is the boundary object, offering a variety of meanings and experiences that create an intersection for people of one country to imagine those of another, "an acceptable middle ground for different viewing constituencies," especially in a time before and between the world wars when so few had traveled among other countries (Berrin 2021, 323). Elihu Root, Secretary of State for US President Roosevelt in 1909, pursued organized cultural outreach internationally because of his belief that "international political conflict stemmed from cultural differences, and that a nation's art could be a useful device to bring countries together and resolve political differences" (9). Nelson Rockefeller, at the time the coordinator of the nation's Office of Inter-American Affairs (1940), "believed a country's visual arts had the power to build bridges of understanding between foreign countries" (141). Berrin explains that these international art exhibitions were and are "a primary way for modern nations to assert their identity" (ix).

Grincheva, in her study of global trends in museum diplomacy, explains that cultural diplomacy was used officially by the USA during the Cold War with the Soviet Union. The original definition of cultural diplomacy for the USA was "the direct and enduring contact between people of different nations […] to help create a better climate of international trust and understanding in which official relations can operate" (Grincheva 2020, 14). Since the late 20th and now the 21st centuries, communication among countries is more fluid than before the Internet or social media, now allowing citizens' voices to contribute to global discussion. This porousness allows groups and individuals who are not government representatives, known as non-state actors, to engage in international relationships in new ways. Echoing the museum field's expanding awareness that museums are not truly neutral in their practices of collecting and exhibiting materials, and never were. They have always been influenced by the power, politics, and preferences of their creators, funders, leadership, and content managers through their creative voices and operational decisions. Grincheva reaffirms this, stating "museums have always been political institutions" (112). In her research, she concludes three characteristics that give non-state actors legitimacy that state actors gain by their political status: expertise, credibility, and resources and alliances, and that museums have all three of these characteristics. The case is easily made that cultural heritage satisfies those same characteristics.

Grincheva takes care to note the difference between cultural diplomacy and cultural relations. Diplomacy, official or unofficial, builds the relationships among nations; cultural relations are longer-lasting (rather than transactional), and developed through mutuality and honesty that builds trust (23). This is important since in many countries there are ministries of culture or departments of antiquities that can lead this engagement and must increase their use of cultural heritage as diplomatic resources on climate change. Yet in the USA there are no such entities (Rockman and Hritz 2020, 8297). The interior-looking National Park Service or the Smithsonian Institution is the most prominent potential voice. Neither has

the diplomatic capacity to advance climate action among nations, and yet both are constrained in developing cultural relationships by their place in or associations with the US federal government. In the USA then, the responsibility for cultural, climate diplomacy lies entirely with non-state actors, such as museums and their peers. Around the world, there are far greater opportunities for non-state *and* state actors to engage with cultural heritage as a resource for finding common ground to acknowledge and address a changing climate.

Raf de Bont, author of *Nature's Diplomats: Science, Internationalism, and Preservation 1920-1960*, focused on the networks of individuals prioritizing the preservation of nature beginning in the 1920s. He introduces the origin stories of individuals providing early and sometimes lasting leadership, identifying the issues they responded to and visions they offered. He opens with the Second International Congress for the Protection of Nature, June 30, 1931, at the Muséum national d'Histoire naturelle in Paris. The opening remarks for the event by Michael Siedlecki state that "the true base of our efforts is science; and isn't science a common good of all the nations?" with the intent being to establish that the conservation of nature, a topic and a force that observes no national boundaries, benefits all of mankind (de Bont 2021, 3-4). De Bont calls these individuals preservationists. He describes their research and protection efforts as diplomatic not because they had official status but because they created relationships among researchers, hunters, collectors, zoos, gardens, parks, and governments all for the purpose of protecting nature. Their organizations were early subnational actors on behalf of wildlife. Over decades their natural and cultural diplomacy became more valued and powerful as it created footholds through the development of animal sanctuaries, global national parks, and urban outposts of zoos and natural history museum partners. Their work, and work through cultural and climate diplomacy, did and can attract wide constituencies to support causes that were and are significant to diplomacy among nations.

Cultural Heritage as a Boundary Object for Climate Diplomacy: Cultural and Climate Diplomacy among Neighbors and Nations

Neighbors

Neighbor to neighbor cultural relations are an overlooked component of cultural heritage diplomacy, being hidden most often behind the more ceremonial events but excelling in the development of strong and lasting relationships.

He'eia Fishpond is an ancient site on the coast of the Hawaiian Island of O'ahu. A private nonprofit, Paepae o He'eia, has been working with the landowner, Kamehameha Schools, to restore, manage, and maintain this 88-acre cultural site and sustainable food system for the community. The fishpond is 600 to 800 years old. When the circular walls of the pond were built on the coral reef, there were no power tools, no backhoes, no chainsaws, just hand-to-hand community effort. Their work created a safer more reliable way to harvest fish and feed the community. The fishpond operated continually until it was breached during a massive flood

in 1965 and left to stand unused until the 1980s. Since 2001, it has been steadily restored and returned to historical cultural practices to increase the food grown on the island. This approach, restoring so many of the fishponds across the island, will eventually reduce the food grown using fossil fuels or brought in on container ships using fossil fuels. The work will also restore cultural connections that reflect Hawaiians' knowledge of the environment and sustainable practices. All over the island, there are fishponds being brought back to viability. Today, when a volunteer comes from off-island or cross-island to He'eia for a community workday, she is asked with the others to speak her name into the history of this place, work alongside 50 new friends to contribute to the community's past, present, and future, and then share a meal. It is cultural, climate diplomacy, an experience that connects a person to the experience for others' well-being, in a culturally specific and climate-smart way, leaving behind a lasting resource for others and for all (experience of the author; Paepae o He'eia, n.d.).

Indigenous Peoples and the Federal Government as Neighbors/Nations

Prioritization of environmental sustainability and expanded recognition of ITK and TEK are fostering partnerships among native representatives and western scientists to capitalize on the tangible and intangible cultural heritage of Indigenous peoples and their care for the land. This is diplomacy among neighbors and nations. A clam garden restoration project on Russell Island in what is now called Canada. A partnership between Parks Canada, ecologists, and members of the WSÁNEĆ and Hul'q'umi'num Nations is based on an exchange of knowledge and resources. Knowledge holders instruct the western scientists on how to keep the garden healthy through seaweed clearing, raking, and cleaning practices that allow water to nourish the clams. Archaeologists, meanwhile, have documented the demise of historic clam beds through forced neglect by the colonization of Native nations and their lands, and by pollution and sea level rise. A member of the Stz'uminus Nation on the team says what he sees as "really important is the two-way learning between scientists and First Nations elder. I see people with a large degree of humility who are working hard to listen carefully to each other and to what we see on the land" (Kauffman 2021).

Similar partnerships between national agencies, western scientists, and Native nations are appearing in the American west; the wildfires are worsening due to drought, heat, storms, and the amount of fuel available to burn—whether a housing subdivision or fuel on the forest floor. Here the cultural, climate diplomacy is the reconciliation of cultural and regulatory practices. First, there is the recognition of Indigenous peoples' cultural burning practices as a tool for managing fire and food, and for producing resources critical for conducting ceremonies and traditional practices in this landscape. Next, there is a century of US federal regulations that have worsened the problem. And then there is the need for a solution that recognizes the requirements of both parties. "By the early 20th century, the U.S. government had assigned … much of tribal ancestral lands to the U.S. Forest Service, Bureau

of Land Management, and National Park Service" which left many tribes with ties to the land they did not control and could not get onto (Long and Lake 2018, 1). This meant no access to land-tending practices such as cultural burns for hunting, food sourcing, and cultivation of natural materials that are part of cultural heritage practice. (These cultural burns are intangible cultural heritage, defined as "the entirety of knowledge derived from the development and experience of human practices, representations, expressions, knowledge and skills; and associated objects and spaces that communities recognize as part of their cultural heritage" ICOMOS 2019, 2.) For that period, federal requirements for fire exclusion reduced frequency, and requirements for fire suppression kept fires smaller and burning less fuel. For the US government, this worked until the 20th century. For the Native nations, it never worked. And now, the combination of more communities built on the edge of forest habitat, the fire reduction practices leaving more fuel to burn, and the climate-driven heat and drought driving more devastating fires—it works for no one. Instead, a blended management approach is emerging. Partnerships between the Klamath tribe and the federal government, and among the Karuk and Yurok tribes in California with their scientist research partners are testing how combining the values of both knowledge sources, western and indigenous, are strategizing solutions better, truly for all (Long and Lake 2018, 10). The partnership approach builds a better understanding of both the problem and the solution. This is nation-to-nation diplomacy, between the sovereign tribal entities and the US federal government. However, not only is this appropriate, thoughtful, and beneficial work, but it is also critically necessary as a buttress for indigenous knowledge. There is growing awareness and concern that indigenous knowledge is being outpaced by the rate and scale of climate changes and other pressures, "that changes in climatic conditions due to anthropogenic influences may be reducing the effectiveness of some local biological indicators ..." (Chand et al. 2014, 447). Chand and colleagues make this statement in relation to weather and seasonal climate forecasts on Pacific Islands, but where it appears in other knowledge areas, the buttressing of the blended management approach offers hope for a more supportive, just, and realistic recognition of and response to this crisis. In these cases, diplomacy on both sides brings new resources to the table for all. Cultural heritage, tangible and intangible, support the Multiple Evidence Based (MEB) approach to understanding and collectively addressing climate change. The act of drawing from all available knowledge strengthens our ability to recognize and act on changes in a broad and responsive manner, that a single approach or design cannot match (Raygorodetsky 2017, 257).

Global Diplomacy: Toward Meaningful Engagement

If "museums become powerful non-state actors of cultural diplomacy when they ... employ ... cultural resources to reach out and mobilize audiences, build international bridges of collaboration across countries, and attract a wide constituency to support cultural causes of diplomatic significance," then cultural heritage can do the

same, assuming the responsibility as a powerful non-state actor (Grincheva 2020, 28). Research on and recognition of the value of cultural heritage in climate action has been rising in tandem with non-state actors organizing. As a result, cultural heritage climate practice has become more sophisticated. A summary of the learning from the last two decades of climate work might look like this:

- Facts do not change minds or influence policy, rather "scientific rationality must interact alongside other factors" (Rose 2014, 522): if they did, the work of the environmentalists of the 1970s would have changed the Anthropocene's trajectory before now.
- Individual actions alone cannot change the rate or trajectory of climate change in a manner sufficient to avoid the most dangerous changes for humans. Widespread public engagement, and significant policy changes are critical for fostering collective transformation.
- There is no right answer or solution to climate change, only continuous improvement using the best available knowledge.
- Systems thinking is critical. The climate is a system, and so are society, the economy, and politics. To change their trajectory requires influencing, disturbing, or disrupting the systems.
- Everyone with the freedom and resources to do so, has a moral responsibility to create shifts in these systems that create better conditions for all, not for specific interests.
- Varied voices co-create responsive and lasting solutions.

Supported by this experience, secure in our knowledge of our collections, and allied with the scientists, cultural heritage professionals can use cultural heritage for neighborly and national diplomacy on climate. To date, the cultural heritage sector has approached climate policy at the local, regional, national, and international levels under the premise that plans affecting culture and heritage should be made with these resources as part of the discussion and planning: not only should the plans reflect the reality of the impacts on these sites, but also acknowledge that sites and resources can contribute to climate solutions for all. Though the movement has significantly raised the profile of the sector in climate action, it has yet to make any difference in negotiations, yet cultural heritage should be at least part of the context for any international climate diplomacy. UNESCO World Heritage sites have been icons of cultural heritage and climate risk (ICOMOS 2019). The sector is using that recognition to expand awareness of cultural heritage in climate change discussions.

If we look at the origins of cultural heritage and institutional diplomacy on climate change in the 21st century, there are at least five seminal events between 2017 and 2019, marking the evolution of the sector's role as "non-state actors." In 2017, US President Trump's withdrawal from the Paris Agreement—the 2015 treaty of 193 nations to work together to limit average global warming to 1.5 degrees Celsius—triggered the creation of the cultural sector's participation in a cross-sector

coalition, We Are Still In. Representatives from museums, zoos, aquariums, public gardens, and historic sites joined sector representatives from city, county, state, national, and tribal governments; major corporations; higher education; and health and faith-based organizations as non-state actors in cultural, climate diplomacy. We Are Still In's first gathering was held in 2018 at the Global Climate Action Summit (GCAS) in San Francisco, California. Also at GCAS, members of what would become the Climate Heritage Network (CHN) gathered for the first time to plan the establishment of a formal international coalition. Some of these cultural professionals had met for the first time earlier in 2018 in England at the University of Manchester and the 2nd World Symposium on Climate Change Communication. In July 2019, the International Council of Monuments and Sites (ICOMOS) published *The Future of Our Pasts: Engaging Cultural Heritage in Climate Action* to highlight climate change's impacts on culture, and to state the case for adjusting "the aims and methodologies of heritage practice" (ICOMOS 2019, ii) and highlight the "immense power of cultural heritage in raising awareness, developing Adaptation and Mitigation strategies and building Social Inclusion and cohesion in support of climate action." of climate change (39). And in November of that year, at the 25th Triennial Meeting of the International Council of Museums (ICOM) in Tokyo, Japan, the council president announced that the next three-year cycle for the association would emphasize aligning its work with "Transforming Our World: the 2030 Agenda for Sustainable Development," United Nations' framework for global development (McGhie 2019, 14–15). The global cultural sector had begun to mobilize as non-state actors in cultural, climate diplomacy.

Negotiations

When nations meet at the United Nations' Conference of the Parties (COP) to negotiate their commitments to reducing the rise in average global temperature to 1.5 degrees Celsius and to build partnerships and recognition for the need to live more sustainably in our shared world, they have rarely invoked cultural, climate diplomacy, but they could.

The climate assessments by the Intergovernmental Panel on Climate Change (IPCC) are what the United Nations Framework Convention on Climate Change (UNFCCC) and the world's national governments use to create their climate policies. The countries create their commitments to the global effort to reduce climate warming in part by negotiating with other nations. They and their negotiators continuously find themselves at impasses as they debate costs and benefits, preferences, economics, impacts, measures, privilege, and responsibilities related to climate change. They approach these negotiations with a mindset that trade-offs are necessary to reach a palatable conclusion for all. This leaves the talks vulnerable to breakdowns, whether between special interest groups sending signals to negotiators and planners, or within governments and among nations.

The mistake is using scientific data, including carbon dioxide levels in the atmosphere and global mean temperatures, as the primary negotiated determination of

climate change action. Those who remain unconvinced will not be swayed "by better models or smaller error bars …. Rather, climate change has to be understood as a cultural and societal phenomenon as much as a scientific one" (Allan 2014, 6). To be successful in establishing shared goals such as commitments to greenhouse gas reduction, reforestation, land protection, or solar investment, it is critical to first identify a baseline of agreement. With conservation commitments and heritage protection both tied to individual and national identity, cultural heritage can be a strong and stable plank in the platform for climate negotiations and agreements. Though some individuals, organizations, and nations who repeatedly resist engagement on climate change may never be convinced, for all the rest, these shared values can highlight commonalities that lead to a common understanding. This is its value to diplomacy. Within communities, with neighbors who are from indigenous groups *and* non-indigenous government agencies, and among nations negotiating at the United Nations Conferences of the Parties, when people value and understand their connection to something as cherished and familiar as these resources, there are fewer areas for disagreement.

The Trouble with Numbers

Understandably the numbers and graphs used to represent carbon in the atmosphere, centimeters and inches of sea levels rise, or the dollars in loss and damage from climate events can support a policy process "by concretizing complicated information for non-experts"; however, "the result is that often numbers get prioritized over stories" (Schipper et al. 2021, 18). This simplification for negotiations and policy briefings creates a limited approach that ignores local context, the local stories that include potential allies for solutions, and the opportunities for more successful public engagement in awareness-raising, response, and solutions. The reductionist approach eliminates the opportunity for systems-based approaches to a system issue: climate change.

Of course, each nation's commitment to a percent reduction in atmospheric greenhouse gases (Nationally Determined Contributions or NDCs) also encourages such an approach. NDCs appear to be solely about the numbers. This ignores the reality that to reach those numbers requires changes in so many parts of the energy, economic, and social systems tied to the fossil fuels that affect those numbers. It sidesteps the crux of the work—implementation. If a neighborhood or nation wishes to change how it interacts with the world around it, it must be able to gather its members in the effort as well, not just the government or a portion of its members. "[A]ttaining goals that are desirable for the society as a whole entails sacrifices, even if only small ones, on the part of individuals" (Hughes 2014, 232). Though change definitely does not rest solely with individuals, it begins with them calling for and following through with changes. Diplomacy at home, among neighbors, in communities, between native nations and national governments, and among countries, is critical for meaningful change. Nations only achieve their goals if those within the nation who *can* respond *do* respond.

For many, the UN Sustainable Development Goals (SDGs) is the best available manifestation of this systems-based approach to creating a sustainable life for humans on earth. Greenhouse gas reduction is only one of the 17 SDGs, #13. The others address health and well-being, equality, education, cities and agriculture, and protection of nature on land and in the oceans—all parts of sustainable social, economic, and climate systems that benefit so many more people around the globe compared to the present day. No solution engages all 17 UNSDGs; no group benefits equally with others through these pursuits; and many are asked to contribute more while some continue to suffer more. There is, though, diversity of need and opportunity, varieties of response and experience. Recognition of cultural heritage in identifying concerns and creating solutions allows for valuing past, present, and future knowledge and experience. It facilitates the appreciation of "plural and co-existing perspectives" that can improve solutions and engagement with those solutions (Schipper et al. 2021, 6). Cultural heritage climate change documentation and reporting, and its use in climate response, can support global policy-making that requires a thorough "contextual understanding" that emissions numbers alone cannot convey (7). Further, this broader contextual understanding is critical for implementing the measures to achieve each nation's NDC; cultural heritage can contribute to establishing the context and engaging neighbors and nations in their varied solutions (5). The humanities, including cultural heritage, can support "an understanding of the complexities of human-environmental relationships, and produce new modes of knowledge necessary to guide global decision-makers" (Holm et al. 2015, 989).

The IPCC Reports

Though cultural heritage is rarely referenced in the UN reports and negotiations, that is expected to change. The definition of proxy data for this book is selected from the IPCC's report. Three authors cited in this book are contributing authors to the IPCC WGI Report Fourth Assessment Report (AR4) (Le Treut et al. 2007) and its "Historical Overview of Climate Change Science"—Rudolf Brázdil, Jürg Luterbacher, and Christian Pfister—using proxy data for reports that include human-observed documentary data. The museum sector must greatly expand the content available to broaden that contribution.

The opportunities to participate may increase. In 2021, the IPCC met virtually with 400 global cultural heritage professionals for advice on the inclusion of cultural heritage in its next scientific reports (experience of the author, December 6–10). The International Co-Sponsored Meeting on Cultural Heritage and Climate Change was held by the IPCC in partnership with UNESCO and ICOMOS. This inclusion in the IPCC report is critical: without it, policymakers at every level overlook the value of cultural heritage as one of their negotiation tools. In the future, negotiating nations will have resources for including cultural heritage in climate diplomacy.

References

Allan, Rob. 2014. *Historical Climatology Meeting*. Conference at the University of Sussex, Brighton, UK, September 10, 2014. https://www.researchgate.net/publication/281584379_Historical_Climatology

Berrin, Kathleen. 2021. *Exhibiting the Foreign on U.S. Soil: American Art Museums and National Diplomacy Exhibitions Before, During, and After World War II*. Lanham, Maryland: Rowman & Littlefield.

Chand, Savin S., Lynda E. Chambers, Mike Waiwai, Philip Malsale, and Elisabeth Thompson. 2014. "Indigenous Knowledge for Environmental Prediction in the Pacific Island Countries." *Weather, Climate, and Society* 6, no. 4 (October 1): 445–450. https://doi.org/10.11175/WCAS-D-13-00053.1

De Bont, Raf. 2021. *Nature's Diplomats: Science, Internationalism, and Preservation, 1920-1960*. Pittsburgh, Pennsylvania: University of Pittsburgh Press.

Grincheva, Natalia. 2020. *Global Trends in Museum Diplomacy: Post-Guggenheim Developments*. London: Routledge.

Hambrecht, George, and Marcy Rockman. 2017. "International Approaches to Climate Change and Cultural Heritage." *American Antiquity* 82, no. 4 (October): 627–641. https://doi.org/10.1017/aaq.2017.30

Holm, Poul, Joni Adamson, Hsinya Huang, Lars Kirdan, Sally Kitch, Iain McCalman, James Ogude, et al. 2015. "Humanities for the Environment—A Manifesto for Research and Action." *humanities* 4, no. 4 (December 21): 977–992. https://doi.org/10.3390/h4040977

Hughes, J. Donald. 2014. *Environmental Problems of the Greeks and Romans: Ecology in the Ancient Mediterranean*. 2nd ed. Baltimore: Johns Hopkins University Press.

ICOMOS Climate Change and Cultural Heritage Working Group. 2019. *The Future of Our Pasts: Engaging Cultural Heritage in Climate Action*. Paris: ICOMOS.

Kauffman, Jonathan. 2021. "Indigenous Peoples Have Been Protecting Clam Beaches for Thousands of Years—Here's Why It's More Important Than Ever." *Eating Well*, April 2, 2021. https://www.eatingwell.com/article/7897133/indigenous-peoples-have-been-protecting-clam-beaches-for-thousands-of-years-heres-why-its-more-important-than-ever/

Le Treut, Hervé, Richard Somerville, Ulrich Cubasch, Yihui Ding, Cecilie Mauritzen, Abdalah Mokssit, Thomas Peterson, et al. 2007. "Historical Overview of Climate Change." In *Climate Change 2007: The Physical Science Basis*, edited by S. Solomon, D. Qin, M. Manning, Z. Chen, M. Marquis, K.B. Averyt, M. Tignor and H.L. Miller, 93–127. Contribution of Working Group I to the Fourth Assessment Report of the Intergovernmental Panel on Climate Change. Cambridge: Cambridge University Press. https://www.ipcc.ch/site/assets/uploads/2018/03/ar4-wg1-chapter1.pdf

Long, Jonathan W., and Frank K. Lake. 2018. "Escaping Social-Ecological Traps through Tribal Stewardship on National Forest Lands in the Pacific Northwest, United State of America." *Ecology and Society* 23, no. 2 (June): 1–14. https://doi.org/10.5751/ES-10041-230210

McGhie, Henry. 2019. "Climate Change Engagement: A Different Narrative." In *Addressing the Challenges in Communicating Climate Change Across Various Audiences*, edited by Walter Leal Filho, Bettina Lackner, and Henry McGhie, 13–30. Cham, Switzerland: Springer.

Paepae o He'eia. n.d. "The Fishpond." Accessed March 12, 2022. https://paepaeoheeia.org/the-fishpond/

Raygorodetsky, Gleb. 2017. *The Archipelago of Hope: Wisdom and Resilience from the Edge of Climate Change*. New York: Pegasus Books.

Rockman, Marcy, and Carrie Hritz. 2020. "Expanding Use of Archaeology in Climate Change Response by Changing Its Social Environment." *Proceedings of the National Academy of Sciences* 117, no. 15 (April 14): 8295–8302. https://doi.org/10.1073/pnas.1914213117

Rose, David Christian. 2014. "Five Ways to Enhance the Impact of Climate Science." *Nature Climate Change* 4, (July): 522–524. https://doi.org/10.1038/nclimate2270

Schipper, E. Lisa F., Navroz K. Dubash, and Yacob Mulugetta. 2021. "Climate Change Research and the Search for Solutions: Rethinking Interdisciplinarity." *Climatic Change* 168, no. 18 (October 18): 1–11. https://doi.org/10.1007/s10584-021-03237-3

6

NEXT STEPS FOR DOCUMENTARY CLIMATE PROXY DATA

The museum profession has two paths for engaging its collections for climate proxy work: 1) share our documentary resources with climate researchers and/or digitization projects for wider access, and 2) use our documentary resources and public engagement expertise to work with climate researchers to access, interpret the story of climate change. The professions must follow both paths. These resources must not remain in hiding. This last chapter focuses on the steps needed to make collections available to climate change research and storytelling.

John McNeil, a professor at Georgetown University, Washington DC, said in an interview about teaching climate history what he anticipated in the next ten years: "I hope we can look forward to more data from the neglected parts of the world; finer resolution for some of the data we think we have; more careful correlation of textual and natural archives on the part of practitioners in the field" (Degroot 2015). He was calling for the identification of more data, especially in areas where there was less documentation or it has not yet been accessed; better examination of existing data and additions to it to make it clearer; and alignment of the documentary *and* natural history data, so that cultural heritage stewards can support the development of that clearer picture. This change has been too slow in coming, but it can be accelerated through an evolution of curatorial practice and partnerships.

Intellectual Access

Information, in this case from museum collections, when combined with information from other sources and the personal experience and motivations of an individual, can contribute to the formation of new knowledge and new understanding (Fraser and Switzer 2021, 29–30). To provide intellectual access is to open the door to that understanding. Currently, there are too many closed doors between

DOI: 10.4324/9781003044765-7

collections information and climate understanding. To open them requires five shifts in the proxy data research universe: 1) greater awareness and understanding of environmental and climate change concepts among the cultural heritage professionals who care for these collections and manage public access, 2) clearer and more complete identification of available museum resources and their contents, 3) expansion of the available climate proxy data resources to include under-represented peoples and under-documented places, 4) expansion and connection of digitized proxy data resources and online databases, and 5) improvements in interpretive methods for humanities proxy data.

Researcher Awareness

Few cultural heritage workers have been trained in environmental and climate change issues. This cannot limit the work to provide access. Regardless of the topic, every curator, registrar, or researcher has had to develop new vocabulary and understand new contexts or information to build the knowledge necessary to interpret collections. Climate change as a topic is no different. Furthermore, the current level of published research, media translations, and professional development provides easy access to basic concepts. These are enough for collections professionals to begin re-examining their collections: the goal is not to master the content but to be able to query it thoughtfully to support any user building their own knowledge. For the museum field to broaden the public it reaches, it must develop professionals who can see their collections as caches of climate change information, and who relish the opportunity to find it in as-yet-undiscovered places.

> *Call to Action:* Be the example. Use conferences, papers, exhibit introductions, museum newsletters, and social media to share how the institution and its staff are developing environment and climate awareness, and why.

Materials Identification

Stefan Brönnimann, in an interview in the *Bulletin of the American Meteorological Society* published in 2020, commented that

> Scientists, laymen, priests, officers, doctors, plantation owners, explorers, teachers and missionaries: They all performed an enormous number of meteorological measurements in the eighteenth and nineteenth centuries – far more than I would ever have thought. Only the long continuous series are well known today, but the numerous short records have now also become available. Unfortunately, a lot of these records are nowadays forgotten or have not yet made it to the digital era. New numerical methods are able to make use of them to reconstruct the daily weather. So we have to go back to the archives and revisit the meticulous work of these people.

(46)

If "we" went back to the archives to look for this material, how would we know where to look? Historical climatologists know how to isolate, then collect, and interpret the data in the records, but first, they must know to examine the records. This means they must know that the records exist, where they are, and what information they are likely to contain. Primack and Miller-Rushing discovered critical resources by talking to people in Concord, MA, who eventually connected them to historical materials—three years after beginning their work. The near-miss is a near-tragedy. How can cultural heritage stewards signal that their collections may have valuable information? They must intentionally examine collections for climate proxy data and document those resources in ways that signal their value to climate researchers. This can be done through keywords for tagging and descriptions, and thematic resources such as finding aids.

The Anchorage Museum's *Climate Change Photography Resource Guide* is an example of a clear finding aid. When paired with other data in a more complete time series documenting climate change, these resources may add clarity to the data or contribute to corroboration. The guide signals to researchers that they may find climate-related evidence in the archives. For this collection, changes to glaciers, structures, and plant materials provided visual evidence of a changing climate. For another collection, themes for finding aids are nearly unlimited: bloom times, bird migration, weather resources, harvest records and agricultural reports, menus in restaurants or for celebratory events, or photographs of special events honoring seasonal changes.

What the field has yet to develop is a body of language for describing, and cues for identifying, climate proxy data in collections. Are there keywords to use that non-scientists would understand and scientists would also recognize as related to climate change? Can there be forms for documentation that are not prescriptive about how and what information should be captured, and instead provide guidance and resources for creating and preserving documents that empower people rather than driving them to align with a pre-existing set of ideals or expectations? (Kate Lee, conversation with the author, March 6, 2020).

> *Call to action:* Those in this field who care, must collectively establish protocols and language to describe collections to make them searchable for climate change content. Partner with climate scientists to explore the subjects and terms.

Source Identification

After establishing basic principles and context for recognizing climate data within source collections, the next step is identifying more of those sources. This book has described many. Surely there are many more, but there are gaps, and some are significant: the under-represented peoples in historical records and the sparsely documented places. These absences can be due to myopia or bias on the part of collectors and researchers, or because some areas of focus truly were documented less than others.

Indigenous resources are likely the most under-represented sources among museum collections with climate change data. And likely, those sources exist but are invisible to unobservant researchers. For example, Indigenous names for land and marine resources are still used. These names are often associated with a resource or condition that may have been affected by climate change in the time between the common use of the names and today. They are clues to proxy data. In the Pacific Northwest of the United States and Canada, "persistent kelp forests" were such important cultural and subsistence resources, and such recognizable features, for Native Nations and First Peoples that placenames identify these kelp beds (Naar 2020, B-4). The information on the location and abundance of those beds may be environmental or climate change indicators. Their persistence (or not) on land and in the sea, and the life that depends upon them, are also indicators. The same is true of clam flats, plant sources, and hunting grounds. Why are they overlooked? Even as these names appear on maps they may be discounted as transient or insignificant. Or they may be remembered and valued only by the people who originated them and left out or ignored by others who do not recognize their value.

For some of the places that have limited extant documentation, scouring for unexpected caches of documents may help fill gaps. Africa is "the world's least developed land-based weather observation network" (Lombrana 2021). There have been weather stations capturing data for over a century, but they are too few for a detailed understanding of climate, so there is search for documentary data to fill in the gaps. Researchers at the World Meteorological Organization know that there is "a wealth of information still on paper in Africa," in archives, libraries, agencies, and related-organization storerooms, some even rescued in recent decades as war and violence threatened to destroy them. Those who recognize the value in these documents have organized work "to hurry up to locate this data on paper, scan it, make inventories and code the data" (Lombrana 2021).

Improving climate change documentation requires incorporating appropriate information in appropriate ways. It is time to create more partnerships among researchers, collecting institutions, and native communities to document climate change. These brief paragraphs can only suggest that there is a considerable amount of work to be done, not how much or exactly where. The data are waiting for those who care to rescue and build on them.

> *Call to Action:* Commit to documenting climate-related data, and especially if the collection may have source data that supports under-represented peoples or includes under-documented places.

Datasets, Digitization, and Databases

The data are information from museums and related collections that are available for research. Datasets are the larger collections of these data from a variety of source collections and types. The sources may be small contributions, such as a farmer's almanac entry for ice-out in Boston Harbor, or a mention in "When Lilacs Last

in the Door-Yard Bloom'd." The source could also be a series of data such as tree-ring series, beginning of grape harvests in Europe, and 900 years of cherry blossom records; and they could be a whole collection of ships' logs, lighthouse record books, or weather station records. When digitized and transcribed, the data become available for inclusion in databases that can provide electronic access to a broad range of researchers.

Brönnimann et al. in their work to inventory pre-1850 instrumental weather records globally conclude that there is not enough data yet made "readily available" (2019, ES405). Much is only partially, if at all, transcribed, and cataloging is insufficient. The inventories need expanding, the cataloging improved, and the material more fully transcribed and made digitally available. Museums must make sure that researchers know what documentary material is already digitized that is of value to their climate studies, and what records *require* digitization to support that work.

The paleontologists who have been looking so intently at environmental changes of the past are a model the history field can emulate. The Neotoma Paleoecology Database is a "community-curated data resource that supports interdisciplinary global change research by enabling broad-scale studies" of the environmental past by consolidating many types of data. Their datasets are of sedimentary archives (Williams et al. 2018, 156). And that dataset is only one among many that are building information practices that allow for sharing data and cooperating in research (158). The Neotoma Paleoecology Database includes museum specimens and uses a coding format that accepts museums' accession numbers (163). The model offers a valuable learning example, though there is so much to be resolved. Issues of data stewardship, data access and linkages, and the details of data management and materials identification, would need to be adapted, and new research questions and paths created.

For database management that includes Indigenous materials, the cooperative approach between the Penobscot Nation in the United States and Canada and the University of Maine is a valuable example of managing culturally sensitive data. The partnership's Memorandum of Understanding addresses both legacy and contemporary collections from archaeological sites that, among other research values, may contain important climate proxy data (St. Amand et al. 2020, 8290). The information access design follows the guidelines of the Indian Arts Research Center (IARC) for digital content management systems. There are also guidelines for museums working in consultation with Indigenous peoples (IARC n.d.).

Mukurtu is a collection management system increasingly used for culturally specific information accessed through online databases. The design ensures that Indigenous peoples can "establish parameters for access to heritage materials" (St. Amand et al. 2020, 8290). It originated with Warumungu community members in Australia in 2007. Today, Mukurtu's open-source code is developed and maintained at Washington State University's Center for Digital Scholarship and Curation through consultations with communities and organizations (Mukurtu n.d.). Mukurtu is being used by the Passamaquoddy, also in Maine, and another 600 Indigenous groups worldwide to curate their materials and access them (Kim 2019).

Members of the Mukurtu team have created Traditional Knowledge Labels (TK labels) for use in Indigenous and non-Indigenous digital archives and collections. These labels identify resources as culturally sensitive materials by provenance, appropriate protocols, and permissions for use, providing on-the-cover signals about appropriate access and use for researchers and community members. These labels signal cultural and historical context, and the political authority to access the contents (Local Contexts, n.d.)

These three innovations—the Neotoma Paleoecology Database, Mukurtu, and Traditional Knowledge Labels—are examples of how research and access can improve while expanding to include more communities and collections, and embracing new practices and research focus.

> *Call to Action:* Explore these and other approaches to data management, then consider how your museums' resources can build on these approaches to connect valuable climate data to those who respect it.

Methodologies

Historical documentation does not use taxonomies of climate change. Until they are added to current records, identifying these data will remain discouragingly time-consuming. The paths of crowdsourcing and digitization are shortening the time necessary for accessing the data once they are discovered, but as the work expands, researchers must continue to create, test, and deploy new methods of accessing and interpreting the information. The advances in calibration and indexing, already described, are two examples of these necessary new methods. What other new approaches are necessary for expanding access to the data in humanities collections?

> *Call to Action:* Recognize that interpretive methods are constantly developing. Examine your abilities and your museum's resources for ways to support the development of improved methods for using documentary materials as climate changes proxies.

Practical Access

The museum sector has significant experience in exhibitions, lectures, and programs, and is building its engagement with crowd-sourcing practices. To expand and improve public engagement in these ways requires partnerships with researchers and access to funding.

Researchers

If it is the curator's job to know the collection, and the researchers' job to understand how the environment and the climate work and how they are changing, then

the only way the work of each is sufficiently thorough and effective is through partnerships. The museum field has a long tradition of holding lecture series with outside presenters. The purpose has been to associate the museum's mission with current research and publicly recognizable academicians and issues. Inviting guest lecturers to present their work expands the intellectual discourse just as borrowing objects for an exhibit expand the interpretive presentation. A visiting object, or a visiting person who shares experiences or research, will expand the narrative, and likely attract more or varied visitors.

Yet simply allowing a researcher access to the collection without building upon the learning and extending the knowledge-building to the museum audience seems like a waste. It is a fleeting transaction rather than a lasting engagement. By partnering with a willing researcher or research group, museum staff not only expands the resources available to the researcher, but also can learn from the researcher, and possibly improve the results for both partners.

Take care, as with any resource consulted, to be sure the museum collection and staff are identified. This citation is standard practice in publications for artworks, direct quotes, and scientific sources; it should also be for collections resources. Yet, during the research for this book, there was very little identification of museum resources on both sides. That citation can lead to further research that benefits other projects and more audiences.

Lastly, seek ways to work with the researchers to bring the results back to the museum for the benefit of staff and visitors. Whether there is an exhibit or new collections notes, a lecture, or a newsletter article, it is very important to capitalize on the good work done and to share these discoveries.

> *Call to Action:* Create partnerships with historical climatologists to share collections for research. Begin by reaching out to the nearest college or university research offices. Then work *with* the researchers to provide informed access to the collection and to build your own knowledge. Offer to share the research effort, co-develop articles and exhibits, and to help the researcher share her results. Require the researcher to name the museum collection in her work.

Funding

Climate change, especially in humanities settings, is under-discussed, under-researched, and under-funded. Yet the window for the most effective climate action that benefits humans is narrow and closing. Too few people are engaged at every level of society and in every type of action to create sufficient change just yet. The museum sector can only scale its contribution to climate action if it scales the research that broadens public engagement. Unfortunately, the competitive funding approaches that follow a lengthy application cycle delay this action and narrow the pool of climate actors (Jensen 2017, 133). As climate change work gains visibility in the museum sector, this research should be prioritized in approaches to funders, and by funders in its support of the sector.

The shortest path to mining collections for proxy data is to create partnerships with funded researchers at universities. They are museums' intellectual partners in this work; sharing physical resources to create extended intellectual access is the clearest path to benefit all.

Alternatively, institutions can make progress by including this work alongside other supported activities such as digitization initiatives, during regular inventory activities, or when describing items added to collections databases; when reviewing thematic resources and outlining exhibition resources; and while training future professionals through internships.

> *Call to Action:* Ask for funding for documentary climate proxy data resources. Tie the work to currently funded activities at every possibility.

Final Thoughts

Professor Alan MacEachern was asked what will be different about teaching historical climatology in 2025, ten years after that interview. He said,

> As with environmental history, there'll be growing acceptance within the history field that this *is* history: that historians have a role to play in understanding past climates and humans' relationships to climate, and that this is history that students – Arts, Science, and Environmental Science students – should know.
> *(Degroot 2015)*

To help make this hope become a reality by 2025 for students and for anyone who visits museums or benefits from their work, this chapter and book purposely end with an overarching call to action: *create more partnerships and highlight them.*

Create partnerships with

- climate change researchers to expand and enhance their resources,
- agencies with climate change data to reinforce museum data and enhance theirs,
- other museums to illustrate the depth and breadth of climate proxies as evidence and story sources,
- Indigenous peoples whose knowledge enriches not only the understanding of collections in museum storerooms but in the world that surrounds us all,
- the public as community observers and as crowdsourced documentation of your collections,
- the media to share local references to global climate change stories, and
- funders to scale research and leverage public engagement while ensuring the funders' understanding of how climate change is not just for scientists.

Then celebrate those partnerships by identifying them in every publication, exhibit, social media message, and press release about the related work.

In partnerships we tell bigger, moving stories, and help more people see themselves in our museum's climate conversations in ways that ask them to come closer, understand more, and see the connection that climate change has to the nature and culture they value.

References

Brönnimann, Stefan, Rob Allan, Linden Ashcroft, Saba Baer, Mariano Barriendos, Rudolf Brázdil, Yuri Brugnara, et al. 2019. "Unlocking Pre-1850 Instrumental Meteorological Records: A Global Inventory." *Bulletin of the American Meteorological Society* 100, no. 12 (December 1): ES389–ES413. https://doi.org/10.1175/BAMS-D-19-0040.1

Brönnimann, Stefan, Rob Allan, Linden Ashcroft, Saba Baer, Mariano Barriendos, Rudolf Brázdil, Yuri Brugnara, et al. 2020. "Instrumental Meteorological Records Before 1850: An Inventory." *Bulletin of the American Meteorological Society* 101, no. 1 (January): 43–47. https://doi.org/10.1175/BAMS-D-19-0040.A

Degroot, Dagomar. 2015. "Teaching Climate History in a Warming World." *Historical Climatology*, December 17, 2015. https://www.historicalclimatology.com/features/teaching-climate-history

Fraser, John, and Tawnya Switzer. 2021. *The Social Value of Zoos*. Cambridge: Cambridge University Press.

Indian Arts Research Center. n.d. "Guidelines for Collaboration." Accessed March 18, 2022. https://guidelinesforcollaboration.info/guidelines-for-museums/

Jensen, Anne M. 2017. "Threatened Heritage and Community Archaeology on Alaska's North Slope." In *Public Archaeology and Climate Change*, edited by Tom Dawson, Courtney Nimura, Elías López-Romero, and Marie-Yvane Daire, 1st ed., 126–137. Philadelphia: Oxbow Books.

Kim, E. Tammy. 2019. "The Passamaquoddy Reclaim Their Culture through Digital Repatriation." *The New Yorker*, January 30, 2019. https://www.newyorker.com/culture/culture-desk/the-passamaquoddy-reclaim-their-culture-through-digital-repatriation

Local Contexts. n.d. "TK Labels – Local Contexts." Accessed March 18, 2022. https://localcontexts.org/labels/traditional-knowledge-labels/

Lombrana, Laura Millan. 2021. "Africa Is the Continent Without Climate Data." *Bloomberg*, August 3, 2021. https://www.bloomberg.com/news/features/2021-08-04/africa-s-climate-data-has-gaps-can-old-books-help

Mukurtu. n.d. "About - Mukurtu CMS." Accessed March 13, 2022. https://mukurtu.org/about/

Naar, Nicole. 2020. "Appendix B: The Cultural Importance of Kept for Pacific Northwest Tribes." *Puget Sound Kelp Conservation and Recovery Plan*. B-1–B-12. Mt Vernon, Washington: Northwest Straits Commission. https://nwstraits.org/media/2925/appendix_b_the-cultural-importance-of-kelp-for-pacific-northwest-tribes.pdf

St. Amand, Frankie, S. Terry Childs, Elizabeth J. Reitz, Sky Heller, Bonnie Newsom, Torben C. Rick, Daniel H. Sandweiss, and Ryan Wheeler. 2020. "Leveraging Legacy Archaeological Collections as Proxies for Climate and Environmental Research." *Proceedings of the National Academy of Sciences* 117, no. 15 (April 14): 8287–8294. https://doi.org/10.1073/pnas.1914154117

Williams, John W., Eric C. Grimm, Jessica L. Blois, Donald F. Charles, Edward B. Davis, Simon J. Goring, Russell W. Graham, et al. 2018. "The Neotoma Paleoecology Database, a Multiproxy, International, Community-Curated Data Resource." *Quaternary Research* 89, no. 1 (January): 156–177. https://doi.org/10.1017/qua.2017.105

INDEX

Note: *italic* page numbers indicate figures.

Printed in the United States
by Baker & Taylor Publisher Services